The Complete Guide to
Limited Edition Art Prints

How to Identify, Invest & Care for Your Collection

Jay Brown

Front cover prints, clockwise from left:
"Majesty on the Wing" © Robert Bateman
"Country Garden" © Paul Landry
"Pintos" © Bev Doolittle
"Dreamer's Trunk" © Dean Morrissey

Published by

 krause publications

700 E. State Street • Iola, WI 54990-0001
Telephone: 715/445-2214

Please call or write for our free catalog.
Our toll-free number to place an order or obtain a free catalog is 800-258-0929 or
please use our regular business telephone 715-445-2214 for editorial comment
and further information.

Library of Congress Catalog Number: 98-87360
ISBN: 0-87341-704-6

Printed in the United States of America

This book is dedicated to
Wood Hannah, Robert Lewin, and David Usher
for their incredible vision and creativity.

Table of Contents

Foreword

Dear Collectors,

My first exposure to the art business came when I was in second grade. My father was the president of the PTA and my mom was a member of a committee of women known as "The Library Ladies," whose passion was to somehow raise enough money to fund a library for my elementary school. This passion caused my parents to stumble upon an art company from Chicago that was willing to travel eight hours to Ohio, set up shop for the weekend, and give a portion of their sales to the school. The PTA agreed to support the project and in 1968, Melridge Elementary School in Painesville, Ohio was transformed into an art collector's paradise, hosting a show of many of the leading artists of the time — Norman Rockwell, Salvador Dali, Alexander Calder and Victor Vasarely.

The show was a huge success and instantly became an annual event. The ladies got their library (though I wasn't allowed to visit it because I was on school restriction for fighting on the bus), but my understanding was that many of the kids benefited from it tremendously.

In 1974 when I was 13, my parents started their own art gallery outside of Cleveland, Ohio. On weekends and after school I would spend time at the store taking care of customers and learning the ropes of the business. (Looking back, I realize my parents got me involved in the business so I would stop setting fires, blowing up neighbors' mailboxes and doing all the other things that young boys do.) Eventually, I attended Ohio State University and in 1983, joined the family art business in a full-time capacity.

From the moment I joined the art business, I spent each and every day talking with the world's greatest artists, their publishers, their dealers and most importantly, my collectors. I learned about each of their concerns — why an artist chose to paint a certain way, how the publishers painstakingly decided what images were print-worthy, how dealers battled continuously with publishers for sold-out product to fill their customer's orders, and the collectors' importance to the entire process.

About six years ago, I started writing down the questions my collectors were asking. Quite often they prefaced the question with "this is silly but...," but their questions were hardly silly. In fact, most of the time I had heard the question time and time before. As I gathered more and more questions, I realized that there was a tremendous need for a collector's guide to fine art prints, and I knew it would make the art of "collecting art" even more enjoyable.

This book should answer many of your questions about decorating, investing, conservation and framing, while providing insight into appraisals, insurance, hanging and the printmaking technology of today. My goal was to create a book that wasn't too technical for the beginner and not too simple for those more advanced. I believe that artists, publishers, dealers and art collectors will find it a very valuable resource. I hope you enjoy it.

Happy Collecting,

Jay Brown

Introduction

The Offset Lithographic Print Revolution

The art of offset lithography is still in its infancy. With only a little more than 30 years of existence, we've seen it revolutionize the art world's perception of the limited edition print.

Consider what the art world was like only two decades ago. Limited edition print enthusiasts collected and invested in original prints — etchings, serigraphs, and stone lithographs. Artists such as Norman Rockwell, Salvador Dali, Pablo Picasso and Alexander Calder, in conjunction with their publishers, would issue their new releases in editions of 200 or 300 prints, and they would take months (if not years) to sell out!

Today an artist like Bev Doolittle can do an edition of 69,996 offset lithographic fine art prints and it doesn't just sell out, but it does so on its release. And furthermore, within just a few months it often becomes highly sought-after on the resale market. That's quite a significant accomplishment in a relatively short period of time. And, it is proof that the offset lithograph is the preferred decorative and collectible art form in the world today. But, why?

Unlike the printing processes for art prints that were most common two decades ago, such as serigraphy, etching, and stone lithography, with offset lithography there is an ability to guarantee continued quality throughout the printing process. Because of this consistency in quality, the process of offset lithography allows for larger edition sizes and lower prices. And, the combination equates to more opportunity for people to become involved in the marketplace.

Also consider the trend in American art that has aided the offset lithograph. Today, America is a country drawn toward realism and none of the other printing processes can compete with the realistic, sometimes photographic quality that is usually associated with an offset lithograph print. Perhaps we're tired of looking at abstract art, composed of lines and shapes, that makes us say "huh?" Today, we want to look at art that has a specific meaning — that tells a story and that speaks a genuine message to our souls.

With the acceptance of this method to create art reproductions, it is now possible to nearly duplicate an original painting and make as many exact duplicate copies as the public demands. Perhaps, if we had the technology 100 years ago, we wouldn't speak of realism as a trend, but as the way the world perceives American art.

It only makes sense that the preferred printmaking method should be the one that exhibits the most current technology, assuming it can complete the process in the easiest, fastest and least expensive way, while attaining the highest quality results. And, this is exactly why offset lithography is the preferred printmaking method of our generation's artists, publishers and collectors.

Just as with other major industries, there will always be the cynics who won't admit that there can be technological advances that improve the market. But, the public is speaking by their performance, and the cynics are being forced to listen.

America loves the offset lithograph for its great quality and proven collectibility. The offset lithograph is not only controlling the art market today, but it is changing the art of print collecting.

1
The Offset Lithograph— Past and Future

In the Beginning There Was Traditional Lithography

In the early 1800s, a printing method was developed that did not rely on raised sections as it did with the etchings and other intaglio prints that were dependent on the cutting, carving or engraving of plates. The premise was based on the simple concept that grease and water do not mix. This was the beginning of the lithographic process, though it had yet to be mechanized.

It's unknown who the first artist was to use the process for the printing of fine art, though the familiar names Currier and Ives were definitely at the forefront of the movement. In the early 1800s they made one-color (black-on-white) prints and then hand-colored them to bring them to life.

The process continued to evolve, establishing ways to add more than one color, until shortly after World War II when mechanization was added and it became the preferred method for magazines, newspapers and various four-color printed items. Using this method, printing became much cheaper, and by the late 1950s and early 1960s it was the only method used for these purposes.

When Frame House Gallery founder Wood Hannah started publishing fine art prints in the early 1960s using this method, he brought the limited edition concept to the movement. Shortly thereafter, the standard for offset prints climbed from four-color prints to today's typical fine art reproductions that often use eight, ten or even more colors to achieve near-perfect reproductions of original paintings.

The Founding Father of the Offset Art Print

The founding father of the limited edition print world was Wood Hannah (1904-1989) from Louisville, Ky. Hannah was a promoter, an astute businessman, venture capitalist, car dealer and all-around entrepreneur. In 1961, he discovered the original artwork of wildlife artist Ray Harm and together they devised the concept of duplicating the paintings as limited edition fine art reproductions.

Initially, Hannah started a company called Ray Harm Wildlife Art. In 1964, they issued their first signed and numbered limited edition print: Ray

Frame House Gallery was the nation's first fine art offset lithographic publisher. (Pictured are some of Frame House's fine art print catalogs)

Harm's "Eagle and Osprey." By 1967, the company had obtained a Louisville art gallery and by 1969 they had changed their name from Ray Harm Wildlife Art to Frame House Gallery. Soon they started adding other artists — Guy Coheleach, Ann Ophelia Dowden, Don Eckelberry, Charles Frace and serigrapher Charles Harper. The first full-fledged publishing company dedicated to offset art reproductions was born. For the next few years, Frame House Gallery single-handedly controlled the market until their success spawned other publishers — Wild Wings in

Wood Hannah (standing, upper right) along with (sitting from left), Ann Ophelia Dowden and Ray Harm, (standing from left) Guy Coheleach, Charles Harper and Charles Frace. (Photo courtesy of Charles Harper)

1967, The Greenwich Workshop in 1972 and Mill Pond Press in 1973.

Interestingly, the first edition sizes were very large, averaging about 5,000 prints per run. But, the prices were incredibly low, with many prints issued for only $10 or $20.

Besides being the shrewd businessman, Hannah was also the forerunner of the concept of using wildlife art to benefit the environment. Proceeds from the sale of selected Frame House Gallery prints went to such organizations as The National Audubon Society and the Nature Conservancy.

By late 1970, after establishing the market for limited edition fine art offset prints, Hannah sold the company for 7.5 million to the Leo Burnett Agency of Chicago, but the company was never the same. Hannah's magnetic personality, generosity, salesmanship, and business acumen could not be matched. Eventually, the company was sold to the Galaxy Group of Houston, Texas, and made part of what is now known as Somerset House Publishing. Two of the original group of six artists, Guy Coheleach (Mill Pond Press) and Charles Frace (Somerset House Publishing) are still active leaders in the world of offset art. Wood Hannah was a man of incredible vision, but he never could have anticipated that today over $600 billion of limited edition fine art offset lithographic prints are reportedly circulating in today's marketplace.

(Special thanks to Ray Harm, David J. Wagner and The Filson Club History Quarterly for information that helped with this section.)

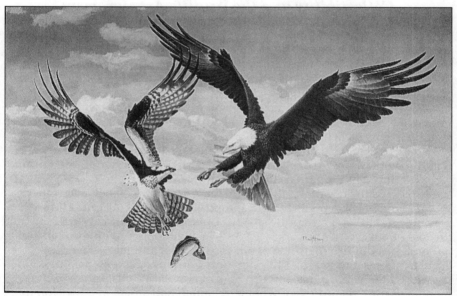

Ray Harm's "Eagle and Osprey" was the very first signed and numbered offset lithographic print published.

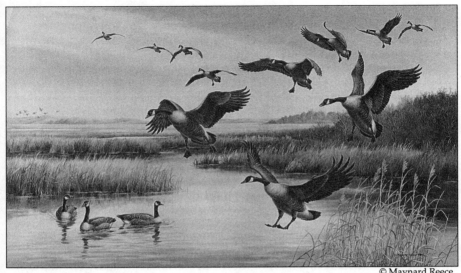

Maynard Reece was the first artist published by Mill Pond Press. (Pictured is Reece's "Careful Landing – Canada Geese")

Collectibility and the Wildlife Art Movement

Wildlife art was at the forefront of the development of collectible offset lithographic art. When Frame House Gallery, originally based in Louisville, Ky., was founded in the early 1960s, it became the first major art publisher focused on the concept of producing limited editions using the offset lithographic process. And, its primary subject was wildlife. Of its original six artists, five were wildlife artists.

But, wildlife art prints did not begin in the 1960s. This was merely the time when people had the idea to produce these works as limited editions. Wildlife prints have been around for hundreds of years. Many people would recognize the name of famed ornithologist John James Audubon. His wildlife works were first produced in the mid-1820s, but wildlife art prints were produced as far back as the 17th century.

Perhaps the use of wildlife art imagery was pure coincidence when Wood Hannah conceptualized bringing collectibility to the offset lithographic art market. Perhaps he saw the burgeoning of our nation's cities and the loss of our woodlands and wetlands in combination with the fears our nation felt about driving some of our most prized animals — pandas, gorillas, rhinos and tigers — to extinction. Perhaps he knew that our country was on the verge of becoming a land of conservationists and environmentalists. But, regardless of whether Hannah had a plan and a vision for wildlife art or not, the feeling of the need to preserve has no doubt helped the wildlife art movement grow and survive.

Wildlife art remained at the forefront of the offset lithographic art world as Frame House Gallery thrived and grew. But, it also spawned competition. In 1967, Wild Wings, a Minnesota based wildlife art publisher, was founded. And, in 1972, The Greenwich Workshop based in Connecticut followed in their footsteps and established a large-scale publishing house dedicated to offset lithographic prints. The Greenwich Workshop's concentration was also on wildlife and Western art as well. Their initial group of artists — Peter Parnall, Frank McCarthy and J. Fenwick Lansdowne — were all wildlife and Western painters.

And again a year later in 1973, when Mill Pond Press entered the marketplace and set up their publishing house in Florida, they focused tremendously on wildlife art by enlisting the help of the top wildlife artists of our time: Maynard Reece (five-time winner of the Federal Duck Stamp); Roger Tory Peterson (famed ornithologist, author and illustrator of *The Field Guide to the Birds*); and Robert Bateman (the foremost painter of the natural world today).

Within a few years, The Greenwich Workshop, Mill Pond Press and Frame House Gallery almost simultaneously recognized that there was a lot more to the offset lithograph than just wildlife reproductions. Other genres, like landscape, floral, maritime and fantasy art began to develop. But wildlife art remained at the forefront of the collectible end of the offset lithographic art industry and it still does.

Trend: Art Continues to Gain Popularity

The days of abstraction and free money are passé. The ongoing trend in American art is realism, price awareness, decoration and quality. The offset lithographic reproduction can provide them all.

Today's art collectors are more interested in subjects that look like something tangible, something that they can relate to — a portrait of idyllic family life, a romantic landscape portraying a cabin or a cottage, or a whimsical interpretation of a humorous or thought-provoking idea. The offset is the best method to replicate the desired art subjects of today.

And then there's price. Aren't we all a little more price-conscious today than we were just a decade ago? It costs so much more to put the kids through school and provide for our own retirement. Today we have to be completely aware of every penny we spend. The offset is the most reasonably priced printmaking method, and that translates into the most cost-effective art form for today's collector.

Collectors also choose offset lithographs for the simple reason that they wish to decorate their homes or workplaces. Unless you're a multizillionaire without a care in the world, you probably select art that you think will brighten a special room in your home or make your day at the office a little more satisfying. With the wide variety of art subjects available today, there's something for everyone. If your interest is wild animals, romantic portraits, pastel-colored landscapes or even contemporary abstracts, the offset has art for you.

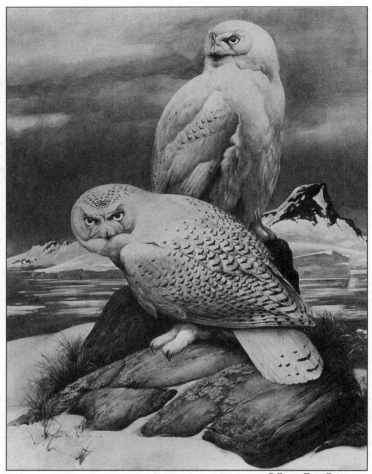

Famed Ornithologist Roger Tory Peterson was the second artist to be published by Mill Pond Press. (Pictured is Peterson's "Snowy Owl")

The other item that drives the trend toward offset reproductions is the quality. With the advances in printmaking technology an original work of art can now be nearly duplicated. In some cases, by reproducing the art onto canvas and adding brushstrokes and highlights, only the most advanced collector can tell the difference between the print and the original.

Over the past quarter of a century a major thrust for offset lithographic acceptance has been heightened by the addition of more and more quality artists, galleries, publishers and most of all collectors into the marketplace. As the market gains more supporters, it continues to snowball in popularity. The offset is not a fad. It is a solid addition to the list of legitimate art media.

An Original Print Comparison

Original Prints

An original print is a piece of art created directly on a printing surface — a plate, stone or screen — without the use of photography. The art is created by transferring the work directly onto the paper by using a combination of ink(s) and pressure applied to the original artwork and the paper of the artist's choice.

Offset lithographs are not considered original prints because they are copies of original paintings made by photographing the original artwork and mechanically reproducing the image using a machine. An "original" print is one where its creation is based on direct contact with the original art.

In theory, if an original print is not reproduced, no completed images exist. The true "original" would collectively be the series of plates, screens or stones that accurately depict the original work. In most cases, the artist creates an original sketch or reference drawing first, but rarely is it a finished original painting.

The most common forms of original prints are etchings, stone lithographs and serigraphs. Traditionally, the artist will personally create the print; however, levels of artists' participation vary. Often the artist will simply oversee the printing process and allow professional artisans (e.g. etchers, lithographers and serigraphers) to do the actual printmaking.

After gaining an understanding of the techniques used to create the various types of art prints, it is easy to identify an original print and differentiate between their unique appearances.

Etchings

I'm a Sagittarius. What's your sign? Haven't we met somewhere before? Would you like to come upstairs and see my etchings?

Yes, etchings are for more than just pick-up lines. Etchings are original art prints made with the help of a metal plate, acid and an etching tool. The process begins with a soft piece of metal, usually copper, that has been covered with an acid-resistant ground. The artist scratches a design in the ground using an etching tool, to expose areas of the metal. Then, the entire

The wide range of offset lithographic prints even includes fantasy and fun as pictured by James Gurney, author and illustrator of the best-selling book "Dinotopia."

plate is immersed into an acid bath, which eats away at the exposed metal areas.

Next, the entire plate is cleaned and all the ground is removed. One should be able to see and feel a series of incised lines that duplicate the design the artist drew with the etching tool. The plate is then inked, and the surface is wiped, leaving the ink in its incised lines. Damp, pliable paper is then stretched over the plate, and placed under high pressure to dry. When the paper has completely dried, and the paper is lifted, the ink will have transferred to the paper, and is recognizable as a mirror image of the initial drawing created on the metal plate.

Etchings are easily distinguished from other prints, because they have an embossed line around the outside of the image. This embossed line is created when the paper, which has been moistened and stretched over the metal plate dries. As the paper dries, it contracts and forms to the edge of the plate.

Also, when looking at an etching, you'll notice that the image is actually composed of a series of lines. The lines are from the initial etching process, and they reproduce clearly after the plate is inked. Furthermore, many etchings are one color initially, because it is very difficult to perfectly register the plates (place additional plates over one another).

Because it is difficult to register etching plates, it is uncommon to create etchings in multiple colors. However, color is often added by the artist or artist's aides who are directed in a way similar to color-by-number. The coloring is usually applied via transparent watercolor paint or colored pencil.

When etchings are hand-colored it is not uncommon for a variance in color and quality to be noticeable between the reproductions. Quite often this is done intentionally to offer originality and unique color options for the discerning decorator or collector.

Distinguishing Traits of Etchings

While viewing art from the back is not as appealing as seeing it from the front, the back of a print can often provide clues that are helpful in determining the printmaking process used.

Look at the back of a print and see if it has an embossed line where a metal plate might have been positioned. This embossed line is the first indication that a print might be an etching. But be careful not to jump to any conclusions. Sometimes a print can be embossed for decorative purposes unrelated to the printmaking process.

If the print passes the embossed-back test, your next step is to flip over the print and examine the front. Does the embossed line offer any decorative purpose or could it be a mark from an etching plate? Is it embossed with a color, like gold perhaps? If you can't determine that there is a decorative purpose to the embossing, then the mark just might be from an etching plate.

Is the print's design composed of very thin marks, dots and/or lines? If the answer is yes, then it's looking more and more like an etching, but to be sure continue your examination process.

If possible, gather a few pieces from the print edition and compare them. Are the papers all embossed in exactly the same place? Etchings generally will have some variance in the positioning of the plate mark. If the prints are colored does the color choice and/or intensity of the color vary from print to print? This would be an indication that the piece is hand-colored, which is another trait of etchings.

If all these questions can be answered yes, then you can cautiously assume that you are looking at an etching.

Stone Lithographs

Have you ever heard a friend refer to his piece of art as a lithograph? Or perhaps you've referred to a piece in your collection with similar pride. Beware, there's a good chance that the reproduction isn't a lithograph in the eyes of the art world. It's really an offset print.

Amateurs and even informed collectors are often misled by the term "lithograph" as it relates to art. The confusion occurs because there are two main forms of lithographs — stone lithographs and offset lithographs. A true lithograph — a "stone" lithograph — is a print made using a stone tablet, a grease crayon and a great deal of hands-on human labor. An offset lithograph is made via photography and mechanization.

The process used for making a stone lithograph begins with the porous rock

© Lynn Kaatz

Wildlife artist Lynn Kaatz captured the rambunctious, yet sophisticated attitude of this young fellow in the print "Two of the Best."

tablet and the grease crayon. The most common stone tablets used are made of limestone and a separate tablet is used for each color application. The artisan first draws an image on the tablet with the crayon, representative of where color Number 1 will appear. Then the tablet is flushed with water. After the water is spread over the stone, a single color of an oil-based ink can be rolled over the tablet. Remember only one color of ink can be applied at a time. Because of the natural resistance of water and oil, when oil-based ink is rolled over the stone it adheres to the grease and is repelled by the water. Then by pressing a sheet of paper against the inked stone, a mirror image of the original drawing is made. If there are multiple copies to make, then the stone is re-inked and another piece of paper is pressed. For each lithograph in the edition, the tablet must be re-inked.

For the second color a new tablet is used. This time the crayon is used to draw the areas where color Number 2 will appear. Then the tablet is flushed with water and rolled with color Number 2. The same piece of paper that was used for color Number 1 is pressed against the tablet. Care is taken to make sure the paper is placed (registered) in the exact position

necessary to keep the image continuous. When the paper is lifted, a two-color lithograph is shown.

The process is repeated again and again until all the colors are applied. The tablets are then destroyed. Upon inspection, each lithograph will often exhibit a distinct or subtle color variation. And, each copy is considered an original piece of art by the art world.

The new trend in stone lithography is to use Mylar (a resilient but thin plastic sheet) instead of limestone. Limestone is cumbersome and expensive, while Mylar is lightweight and inexpensive. The artist draws their image on the Mylar and then it is photographically transferred onto an aluminum plate and printed. Because photography plays an integral part in the process, the prints made with Mylar are viewed by critics as something between an original lithograph and an offset reproduction.

Distinguishing Traits of Stone Lithographs

Unlike etchings, which have the discernible advantage of the embossed line formed by the etching plate, it takes more knowledge and experience to identify a stone lithograph.

The first step is to examine the print and try to determine if it has a photographic quality. Because of the nature of stone lithography there is an inability to create the work showing the spectrum of color variation that is evident in a photograph.

Next, take a look at the intensity of the colors. Generally lithographs are soft and muted. The pigment used doesn't have the brilliance of a photograph.

What about the registration? Are the colors perfectly fluid and aligned? If you look closely, can you see where one color ends and another begins? With stone lithographs often there is a slight overlapping of the colors and the imperfect registration is evident upon inspection.

Another indication might be the paper quality. Normally, stone lithographs are printed on a very high-quality, cotton rag stock. Generally it is very soft-looking and somewhat pliable. It is also common to see a hand-torn or naturally rough (deckled) edge on the paper.

You might also give credence to the edition size. Since stone lithography is a very labor-intensive medium and due to the physical limitations of the stone, the edition sizes are generally small. Most will be in the range of 300 prints or fewer.

Finally, if you have the ability to compare multiple prints within the edition you'll notice variations in the quality and the color. Remember that each piece is printed separately with hand-applied ink and each piece is placed on the tablet by hand. Variations are inevitable.

Serigraphs

Some people know serigraphs by their more common name "silkscreen," and are more familiar with it as the process used to add words and designs to T-shirts. But, art aficionados know of the process by its official, artsy name, serigraphy.

Charles Harper's "Upside Downy" is an example of a fine art serigraph.

Serigraphs are created with a wooden frame stretched with silk and carefully cut pieces of celluloid. The silk is stretched taut and then the pieces of celluloid are affixed to it to form a handmade stencil. The stencil is then laid over a piece of paper and using a squeegee, paint is spread over the contraption. The paint seeps through the uncovered areas. When the frame is lifted an image appears that replicates the stencil.

If a multi-color image is desired, the artist creates another stencil and repeats the process again and again until all the colors are applied. Each time the artist applies another color he must be very careful to place the paper in the exact aligned spot so the registration remains perfect and the image looks continuous.

Distinguishing Traits of Serigraphs

If you analyze the intensity of the color, the registration and the size of the print run, you may be able to determine if the printing method used was serigraphy. However, you'll have to take careful note of one other detail and that's how the paint lays on the paper. Generally the paint appears thicker with a serigraph print than with a stone lithograph. Upon close inspection it may even appear to be laying on the paper as opposed to being absorbed into it.

Because the paint lies on the paper, serigraphs are usually very brilliant in color. In many cases so much paint is applied that you can actually feel the weight when the unframed print is held up.

The registration may also provide insight as to whether the print is a serigraph or not. Since each color is applied separately there is usually imperfect registration and often a small overlapping of the paint. Because of the thickness of the paint applied, you can often determine what colors were applied and in what order.

Like stone lithography, the edition sizes are usually in the maximum range of 300 prints due to the labor-intensive production and the life span of the stencil. Serigraphs are very rarely photographic-looking and are commonly used for abstract and contemporary scenes or impressionistic images.

3

The New Generation – Fine Art Offset Lithography

Fine Art Offset Lithography Defined

Offset lithography is the printing process that creates the highest quality reproductions possible from an original painting. In offset lithography (also known as photo-offset lithography, photo-lithography, planography, offset, photo-offset and lithography), a large rubber roller, or "blanket," lifts the ink from a printing plate and transfers, or "offsets," it to paper using gentle pressure. The final result of this procedure is called an offset lithograph.

Offset lithography is based on the principle that water and grease (or oil, or, in this case, printer's ink) do not readily mix. The offset lithographic printing press uses plates whose image area is receptive to grease (ink) and whose non-image area is receptive to water. Photographic and chemical processes create the water and ink-receptive areas on four separate plates — one for each standard ink color.

Standard printer's ink colors are also known as "process colors;" they are cyan (blue), yellow, magenta (red) and black. These four colors are broken down into networks of dots, which create what the eye perceives as hundreds of thousands of different colors.

Most "four-color" or "full-color" printed pieces, which include everything from books and magazines to greeting cards, brochures, product packaging, and even cereal boxes — are created using this four-color offset lithographic process.

When artists want a photographic-quality reproduction made of their original work, they choose the process of offset lithography. While similar to the four-color process used to create magazines and brochures, fine art offset lithographs exhibit one major difference — the quality. In fine art offset lithography, highly skilled technicians can use more than 25 colors of ink (in addition to the four basic process colors) to create a print that replicates even the most minute nuances.

You may wonder why, when the four process colors can reproduce hundreds of thousands of colors, fine art offset lithographs need so many

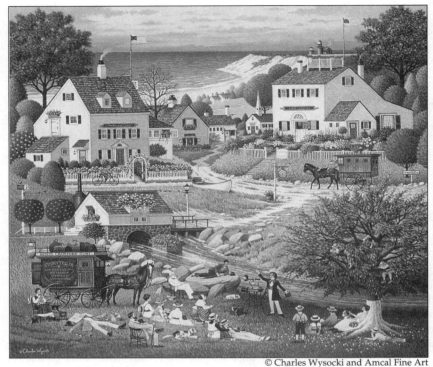

Known for his best-selling Americana Calendars, Charles Wysocki has developed a huge follow-ing in the offset lithographic print field. (Featured is Wysocki's "Hound of the Baskervilles")

extra inks, or "spot colors." Technical reasons aside, the answer is simple: artists paint in so many layers with so many traditional colors and so many unique colors, created through mixing the paint, that it is impossible to accurately duplicate their works with just the four standard process colors. In many paintings, the mid-tones can be easily reproduced using the process inks alone. But without extra colors to bring out the highlights and deep shadows, not to mention the pure pigments many artists use (which are nearly impossible to copy using the four-color process alone), the resulting print would be flat and lacking in color intensity!

Since the lightest highlights and deepest shadows are, in general, the last areas an artist paints, applying spot colors after the basic four gives each print added dimension. The "spot colors" make light areas more defined, bright colors brighter and dark areas richer. In short, these extra colors make the fine art offset lithograph the best possible method of reproducing an original painting. They are the finishing touches that mean the difference between an ordinary offset lithograph and a masterpiece.

If you think of an offset lithograph, as it relates to the art world, as the highest quality reproduction of an original painting attainable by man, then you have a clear understanding of why an offset print is the best way to reproduce art.

The Fine Art of Offset Printing

The first steps in making an offset lithograph are the responsibilities of the artist and the publisher. The artist must paint a work that collectors will find appealing, then the publisher must determine the edition size and the image size. After these decisions are made, the original artwork can be delivered to a printer who will begin the painstaking printmaking process.

© Carolyn Blish

Carolyn Blish's portrayal of children, dunes and beaches have become her trademark. (Pictured is Blish's "The Conch Shell")

Production begins with photography. By using a series of color filters, individual negatives for each of the four process colors are produced in cyan, yellow, magenta and black. Then the negatives are mounted, one at a time, to a piece of clear glass and the negative images are projected through a camera lens and a grid pattern (similar to a screen door). The result is a dot pattern known as a halftone or screened positive. One positive halftone image is created for each of the four process colors. Then proofs are made, compared to the original artwork, and corrections made.

If the proof shows a lack of color intensity in a specific area, the rest of the image is masked off and the corresponding dots are increased in size. If the proof shows that an area is too intense in color, the dots in that area are decreased in size.

After these corrections are made, the film is "stripped," or mounted and aligned so that all four colors register perfectly on the press. When the stripping is complete, each film positive is ready to be transferred to a metal plate.

To transfer the film to a metal plate, it's placed against a thin sheet of aluminum that has a light-sensitive coating. Using powerful lights, the dot pattern for each color is transferred to separate plates. Then the plates are submerged in a developing solution. When removed from the solution, the dot image is visible on the metal plate.

This method is still used by many printers today, however, with the advent of new computer technology, the trend is to do all the pre-printing steps digitally before the plate-making using a computer. In either case, after the plates are made both of these techniques follow the same basic printing process.

The plates can now be mounted on their corresponding plate cylinders inside the printing press. An inked roller within the press covers the image on the plate and then a water roller washes across the plate. The water

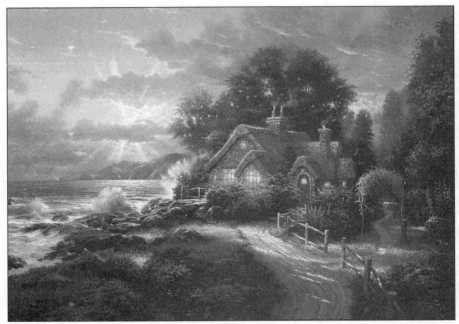

Thomas Kinkade's romantic hideaways have made him one of the nation's leading artists. (Pictured is Kinkade's "A New Day Dawning")

adheres itself to the areas that lack the ink, including the tiny areas between the dots. Then a rubber roller picks up the image by rolling across the plate, which is in turn transferred, or "offset," to the paper. This procedure is repeated for each of the process colors — cyan, yellow, magenta and black — and the result is a four-color, or full-color proof.

When a four-color magazine or brochure is printed, approval of the four-color proof is given, in most cases, right away. But, with a fine art offset lithograph, additional inks may be needed to bring out the colors of certain areas. These are called spot colors or touch colors. This is the biggest difference between a fine art offset lithograph and any other printed product that is created using the process of offset lithography.

These extra colors help produce a more accurate reproduction of the original work of art. They can intensify a specific area of light color, dark color or unique color. And, each time a spot color is needed, the technicians must repeat the masking process, create new plates and pass the paper once again through the printing press.

At this point, a proof is normally forwarded to the publisher, who usually consults the artist for final revisions. Once the reproduction is approved, the final press run commences.

The use of colorful brushstrokes have become Ed Posa's trademark. (Featured is Posa's "First People")

Why is it Called an "Offset"?

"Offset" is another word for "transfer."

In offset lithography, a large rubber roller passes over an inked printer's plate made from a photograph of an original painting. This image is picked up by the roller as a reverse image and the impression is transferred to the paper as a positive image. This transfer, or offset process, reverses the original plate to keep the image from being duplicated in reverse.

To better understand the theory, think about how a rubber stamp works. When you look at a rubber stamp it is a mirror image of the words or image that you want to apply. However, after the stamp is inked and pressed onto the paper, it appears right-side-up, just the way it was intended.

Destruction of the Printing Plates

With original printmaking methods, the plates are deliberately scarred or destroyed so no other reproductions can ever be made from them, thereby protecting the integrity of the edition. Etching plates are placed in an acid bath, serigraph screens are cleaned off, and the blocks used for stone-lithography are broken. However, with offset lithography, no conscious effort to destroy the plates is necessary. The fragility of the plates often causes them to bend and crimp when they are removed from a printing press, making them unsuitable to reuse.

Offset lithographic plates are made of very thin aluminum and a

separate plate is needed for each color. After the plates are created they are bound tightly around a cylinder and the process begins. When the process is finished the plates are taken off the cylinder in preparation for the next colors or the next job. If someone was to gently remove the plate with the idea of perhaps using it again, they might spend a great deal of time trying to get it off without it bending or crimping. It's a very thin aluminum. Then they'd have to carefully reattach it. In reality it would be fruitless. If another plate was warranted, it would only take an hour or so to create it. Therefore, after the plates are removed, they are generally folded up and recycled.

The integrity of offset lithographic editions is more a matter of ethics. In order for a publisher to earn the loyalty of the public, its artists and its dealers, they must keep their edition sizes authentic and legitimate.

Distinguishing Traits of Fine Art Offset Prints

Determining whether a fine art print is an offset lithograph or another type of print can be quite easy if you know what clues to look for. One of the simplest things to look for is copyright information printed in the margin. Generally, it will appear as crisp type, similar to the type produced by a typewriter. Very rarely will any copyright information appear on a stone lithograph, etching, serigraph or any other print produced using other well-known printmaking methods. The copyright information usually includes the title of the piece and the artist who created it, the publisher's name and address and the year of its creation. You may also see the universal copyright symbol "©."

Upon inspection with a magnifying glass, an offset lithographic image is made up of tiny dots. The most evident dots will be from the four main colors used in the processing — cyan, yellow, magenta and black. Also, upon inspection it will be noted that the edges of the image generally appear hard and straight without any blurring or coloring outside of the lines. The registration (lining up of the colors) will appear perfect. And, the ink used will appear to have no texture.

Another indication that the print may be an offset lithographic print is the way the colors rest on the paper. They'll clearly be on the same plane as the paper. There will be no distinguishable overlapping of color and only rarely will there be any embossed or debossed areas. Occasionally, a publisher may emboss or deboss areas to create a special effect. But, with an offset lithographic print, this type of marking has no correlation to the use of a printing plate as can be seen with an etching. This effect is rather a manipulation of the paper after the image is printed.

Overall, the use of a magnifying glass can provide you with conclusive evidence that the print in question is an offset lithograph. If the dots appear, you should feel confident that you've uncovered the printmaking method, and there's really no need to examine the print further.

4

The Papers and the Inks

The Longevity of the Ink

Did you ever look at your favorite print and wonder what people might think of it generations from now? Would they be able to feel the emotion, the texture and the story? Or would they interpret it differently, perhaps seeing a polar bear as we now see a dinosaur or a primitive image as tomorrow's cartoon? It's hard to know how they might interpret our art. But, if they're looking at the art prints that have been hanging on our walls for years, unfortunately they'll probably interpret them as contemporary images of orange and yellow design that lack texture and definition. That's all that will be left when the inks fade and the paper begins to show signs of age.

The inks used today by most printers are state-of-the-art. They're extremely fade-resistant and the best available, but they're not permanent and they can bleach out and disappear with time. The fading generally progresses slowly, so it's very rarely noticed until it's

Jim Daly's art portrays children at the turn of the century, just being kids. (Pictured is Daly's "All Aboard")

© Jim Daly

John Weiss' art shows the warmth and sensitivity of man's best friend. (Pictured is Weiss' "All is Well")

too late. And, today the progression can take two or three decades or more.

Offset lithographic prints are made up of four main colors and the life of each color is different. The first color that begins to disappear is yellow, which results in a print that looks overly blue, red and black. The colors that are created with yellow on the color chart like green and orange will become absent at this time as well.

Next, the red begins to disappear, resulting in a print that appears practically monotone — just blue and black. The blue fades next, followed by black. All that's left is the white of the paper (unless it happened to be exposed to acidic materials or wasn't truly 100 percent acid-free as promised, in which case it can change color as well).

Take precautions. Keep your prints out of direct sunlight and away from the harmful ultraviolet rays of the sun. Also, try to avoid fluorescent lights and lights that stay on much of the time.

You can also make a conscious decision not to frame your prints and just put them away in a drawer or closet. That'll solve the fading dilemma, but there's very little enjoyment in sitting in your closet trying to see a work of art in the dark. It can also be pretty darn lonely.

The Standards for Paper Quality and Longevity

Unless you own a paper mill or have been in the world of art printing and publishing for years, it's nearly impossible to know for sure that a piece of art paper is made of the right elements to last a lifetime. From the collector's standpoint, you want the paper to have enough body and rigidity so it won't bend and get dinged up with reasonable handling. And, you want the content of the paper to be pH neutral so with reasonable care it won't discolor with age.

Today, most art paper is pH neutral — either acid-free or all rag. If it is kept in a dark and dry environment, it should remain crisp, white and fresh-looking indefinitely. However, if it is exposed to outside elements such as light, humidity and dirt or even improper framing materials, impurities can eventually permeate the paper causing it to show signs of age.

Coated Papers

It doesn't take a scientist to understand that if you spill a glass of milk on your living room carpet, that it will soak right into the fibers. But, if you spill the same glass of milk on the kitchen table, it'll sit on the surface. And, that's the same philosophy that paper makers, printers and publishers use to determine the best paper for a limited edition print.

There are two basic types of art paper — coated and uncoated. Uncoated paper allows the ink to penetrate into the paper fibers with little resistance. The result is a print with a soft look and a more artistic feel. The other option is a coated stock, which resists the natural tendency of the ink to penetrate the paper and allows the color to rest on the surface fibers to dry. The result is generally a more brilliant and colorful print.

Both types of paper are very acceptable and equally valued in the print world today. In the past, coated papers were considered cheap and they were reserved for posters and other less-expensive prints, but not any longer. Nowadays, printers use whatever it takes to make the print look more like the original piece of art.

A Word About Borders

The one to three-inch border found around nearly every limited edition print serves a number of purposes and is considered a part of the actual print, even though it's often just blank white space. It provides an area for handling the art without getting fingerprints directly on the image and it also provides an area for the publisher to typeset a title, denote a line or two about the history of the image and include important copyright information. In many cases, it also provides the necessary space that artists need to apply their original pencil signatures.

The standard in the American print market has been to print offset lithographs on white paper with a matching white border. In Europe, the standard is still to use white paper, but to print a cream edging about one inch wide around the perimeter of the image. The European way has technical and aesthetic drawbacks. First, as prints are exposed to light, they

© Carl Brenders

Harley-Davidson Motorcycles authorized this print by wildlife artist Carl Brenders. If you look closely, you might be able to see the bird perched on the side mirror. (Pictured is Brenders' "Free as the Breeze")

are at constant risk of fading. Colors like cream, which have yellow in them, generally fade first. Subsequently, the border color of European offset lithographs often experience changes in tone. Secondly, the colored border is limiting for certain frame designs.

However, the color of the border isn't very important. Understanding that the border condition has a great deal to do with the investment value of a print is important. Should someone take a knife or a pair of scissors to the border of a print, then the value of the work will be diminished tremendously.

Borders are the Rodney Dangerfield of the art world. They are often just tucked underneath a mat where nobody seems to care about 'em. They just don't get no respect! But, if you want your print to hold its full value, you'll give the border the respect it deserves.

The Deckle Edge

Sometimes it can be a good thing when an art print is torn. Sound crazy? Well, with some high-quality paper stock, the edges are hand torn or milled to appear rough in an effort to give it a more arty appearance. It's all part of the presentation, just like the folders that protect the print and the authentication that explains it. It's like the sizzle that accompanies a good steak.

If one print from a print edition has a deckle edge, rest assured that all the other pieces from the run do as well. It's a high quality "perk" done by paper mills, that has become a tradition with the best fine art prints.

5

The Canvas Print Revolution

The Canvas Print Defined

The most recent advancement for offset lithographic art collectors has been the development of processes that can take the artist's original paintings and replicate them on canvas. The philosophy is brilliant in theory and is revolutionizing the way the art world views the limited edition print.

The goal of any art reproduction is to make it look as much like the original art as possible. Until recently, if an artist painted their original art on canvas, the print had to be reproduced on paper. Also, the original art could be displayed without glass and matting, while the print would need both for protection. In reality, when the paper print was framed it didn't look like the original art — it looked like the print that it was. Today, we can replicate the original painting as a print on canvas. We can display it without glass and matting. And, above all we can make it look not like a print, but like an original painting.

Normally the canvas print reproductions are presented on a stretched canvas, just like the original art. They still carry the traditional hand signature and numbering, just like the paper reproductions, and they are often coated with an ultraviolet protective coating which helps the inks resist fading. With reasonable care they should last a long time, if not forever.

To keep a canvas print clean, all you need to do is wipe the image off with a very soft cotton cloth. If necessary, a little distilled water can be added to make the cloth tacky. If the piece gets extremely soiled from a spilled drink or from smoke damage, a restorer can often clean the picture off and bring it back to mint condition.

So far, public response and collectibility of canvas prints has been tremendous. Because it's a rather new movement and relatively more expensive than the traditional paper print (about twice the price), a number of publishers are releasing split limited editions — a portion of the edition on paper and a portion on canvas. The publishers who have been doing canvas prints for a while are finding that the canvas editions now sell out faster than the paper editions; and the collectors are finding out that the secondary market is showing greater increases in demand for the canvas as well.

Diane Graebner's simplistic style aids in her portrayal of the simple life of the Amish. (Shown is Graebner's "Sunday Meeting Hooky")

It's important to understand that this is a new process. It hasn't proven itself to withstand time as other, more traditional reproduction methods have done. But, the experts do feel it's a viable process and a number of the nation's leading artists and publishers are showing strong support for the technology by releasing more and more canvas reproductions every year.

The Fine Art of Canvas Print Production

There are two main ways to produce canvas prints — canvas transferring and printing directly on the canvas. Both techniques produce high-quality results that, based on today's technology, come as close as possible to replicating an artist's original painting.

There is no doubt that the goal when making a reproduction is to make it look as much like the original art as possible. For years, the best technology could only offer reproductions onto paper. If the artist had painted their original work on canvas and displayed it glass-free, then the paper print that had to be displayed with matting and glass was a far cry from the original. The new canvas printing technology has taken the art of the reproduction to the next level.

Canvas transferring is the most common of the techniques used today to make canvas reproductions. The process begins with a standard offset paper print made in the traditional fashion from the original painting. Then the print is coated with a series of special chemicals designed to allow the paper and the ink to separate. When the paper is removed, an ink film remains. Then the canvas is prepped with an adhesive and the film is carefully laid upon it. Pressure is applied, which bonds the film and the canvas together. The canvas is then set aside to dry.

How many snowshoes can you find in this clever work by Scott Kennedy? (Pictured is Kennedy's "Snowshoes")

The other common canvas print making methods rely on printing directly on the canvas. One method is direct offset printing. Simply, a piece of canvas is run through the offset press in a fashion no different than the way a paper offset print is produced.

Other methods include Repligraphy, which uses a hot-melt color-dye printing system, creating an oil-based film that adheres directly to the canvas; and Artagraphs that feature a mold of the artist's original brush strokes and texture.

All of these processes are rather new and have yet to stand the test of time. It seems logical that the techniques that feature direct printing on the canvas will be the future of printmaking. With this method there is no risk of the film, which is adhered to the canvas, delaminating or separating, a problem that can occur any time something is glued with an adhesive to something else. For now, however, these processes are revolutionizing the print world and they bring great excitement and anticipation to artists and publishers worldwide. As the art reproduction technology embarks on a new century of development, canvas printmaking appears to be poised to take over the art world.

Adding a Few Little Highlights

"A little dab here and a little dab there" is becoming the way for canvas prints. "Highlighting," as it is commonly known, is the process of applying paint on a canvas print to give it an element of texture and further the original art illusion. A number of artists actually do their own highlighting. However, some prefer to defer the work to artisans who either work directly for them or the company responsible for producing the canvas prints.

In most cases a template or map is created identifying the areas where the artisan should apply their oil paint. However, because the process is hand-done as opposed to machine-done, there can be slight

Thomas Kinkade's limited edition prints on canvas all include highlighting. (Pictured is Kinkade's "Morning Glory Cottage")

differences from one print to another. To help assure consistency between the images, with smaller print runs, the same artisan normally does all of the highlighting. With larger print runs this isn't usually possible. Most highlighted prints will have between 30 and 100 areas painted. The highlighting can range from a pinhead-sized dab, to a one- or two-inch-long stroke.

If you are wondering if your canvas print has been highlighted, take a look at the print from the side under good lighting. Usually, the texture will be evident. If you're still not sure, you can lightly wipe your hand across the print and if it has been highlighted, you will undoubtedly feel the texture. Remember that touching the print is never recommended, though.

Distinguishing Traits of Canvas Prints

Let's hear a round of applause for the world's printers, publishers, and artists. They must be doing their job pretty darn well. With their textures and highlights now becoming more the standard than the exception, they are making it harder and harder for collectors to differentiate a print on canvas from an original painting.

Many of today's offset lithographic artists publish their prints on paper and canvas, including Greg Olsen. (Pictured is Olsen's "Melodies Remembered")

Eventually, prints are going to be duplicates of original art. It's inevitable. But until the day comes that DNA testing is the only way to determine what's what and which is which, there will be clues that collectors can look for to help them make the determination.

The first clue is always to look for limited edition print numbers. These are normally found on the bottom right or left of the work in the standard xx/yy format. If they are evident then the question is answered — it's a print. However, if the numbers are not visible, then the work in question could be an open-edition canvas print or just numbered in a less traditional spot.

The next thing that a collector can look for takes a little practice. Canvas prints are generally either completely flat or they have little applications of hand-applied paint called highlights. If the picture is completely flat to the touch, then it's probably a canvas print reproduction. With most original paintings there will be areas of texture, sometimes only slight like that in an acrylic painting and other times severe, as with an oil painting created with a palette brush. When there isn't even a fragment of these textures, then the picture is most likely a print.

If the art has little applications of paint instead of the traditional broad brushstrokes, then that's what is commonly called canvas print highlighting. The highlights are normally applied during the canvas printing process by trained artisans. Each highlight is simply a "dab" of paint — much different than a normal artist's brushstroke.

If all else fails, get a high-powered microscope or magnifying glass and look carefully at the image. If it is a print, then it may have been created using the canvas transfer process or direct offset printing onto the canvas. Either way, it's simply an offset lithograph on canvas and it can be identified by the standard dot pattern visible on all offset lithographic products when magnified.

And, last but not least, don't be afraid to consult a gallery that represents original art and canvas reproductions. The differentiating of a canvas print from an original work of art can be very difficult if you haven't done it a few times before. And, as the next round of technology takes the canvas art reproduction to the next level, it's going to get harder and harder to arrive at the correct conclusions.

Within the next few years, it's likely that prints will be made so well that they'll truly be duplicates of the original art. When that day comes, we'll not only provide a round of applause for the offset lithographic art industry, but we'll make it a rousing standing ovation. The industry will have reached perfection.

The Future of Canvas Prints

Canvas art reproductions are the future of the art world. They have the ability to revolutionize the way we perceive art prints, and they will undoubtedly be the choice print medium for the next generation.

Over the next few years you can expect to see nearly every artist that paints in oil and acrylic, as well as the other various mediums that don't necessitate being covered with glass, to move to canvas prints. It only makes sense. If the goal is to replicate the original art as similarly as possible, canvas prints are without a doubt the future of print collecting.

For artists that generally paint on paper and board — watercolorists for instance — the paper reproduction best replicates their work. So, the paper print will probably never go away, it will just be used more selectively to capture the specific painting techniques that it best replicates.

6

The Print Publisher

The Role of the Publisher

The art industry works best when there is a combined cooperative effort among the artists, galleries, collectors and the publishers. Ideally, each will perform their role to perfection — the artists will paint the perfect paintings, the galleries and publishers will make the world aware of them and then desirous collectors will purchase every last one of them and enjoy them for eternity. However, the publisher is most important to the system. The publisher is the major risk-taker and investor in the process and their efforts are critical to nearly every print's success or failure.

As the driving force behind the print artist, the publisher must analyze each submitted painting to determine if it would make a viable print. If they think the market would have interest in the image, then they must determine how many copies the market can bear — and keep in mind that not every spectacular painting makes a great print. The most beautiful painting of a warthog may not have the same amount of interested collectors as a so-so painting of a wolf.

If the publisher thinks the painting has viability in the print world, they must then determine how many prints to produce. Their decision is most often based on economics and collectibility. Should they produce the image in a short supply to encourage collectibility or should they produce it in a large supply to encourage exposure? Should they issue it at a higher price to offset the price to produce a smaller edition or should they release it at the lower price made possible by a larger run?

After these decisions are made and the publisher arranges to have the print produced by a quality printer, the real challenge begins. The publisher must now promote the print to their representing galleries and collectors to make sure that the piece sells. This is where a print can either become a rousing success or an embarrassing and costly failure.

The publisher must sell the work to the marketplace through persistent and effective promotion. Many offset lithographic publishers issue monthly newsletters to galleries and collectors that present their artist's newest releases. They advertise for their artists in magazines and other periodicals, and they arrange artist appearances and sponsor regular conventions for their dealers.

The success of an artist is based on promotion and letting the world know that the artist and his or her prints exist. The publisher is the most

© William S. Phillips

Military history and aviation buffs are big collectors of the art of William S. Phillips. (Pictured is Phillips' "Time to Head Home")

responsible entity in making that happen, and making the system work. Their job is often overshadowed by the attention and recognition the artist receives. But, without the publisher's expert direction and support, many artists and gallery owners might be selling shoes today instead of art and many art collectors might be more interested in Beanie Babies and stamps than prints.

Decisions, Decisions: What Image to Print?

It's a wolf. It's a pinto pony. It's a bird. It's a plane. It's S-u-p-e-r-print! The world would be a better place if you could throw an artist in a phone booth and they'd come out every time with an "S" on their chest and a winning, print-worthy image under their arm. But, unfortunately it's not that easy. Artists and publishers use painstaking thought and determination when deciding whether a beautiful painting would make a viable print.

The artist and publisher can't simply decide if a painting is a technical masterpiece, or a statement of intrinsic beauty. There are hundreds of thousands of award winning, museum quality paintings that wouldn't make great prints because the consumer response wouldn't be strong enough. But what the artist and publisher must decide is if 500 or 1000 people would be driven to purchase the image. They also have to take into consideration how the release of the image as a print might affect the artist's career. Too many weak images might hurt consumer confidence in an artist. One strong-selling release after another might propel an artist's stature in the marketplace.

© Alan Bean

Astronaut Alan Bean was the fourth man to walk on the moon and he is also a very sought-after offset lithographic print artist. (Pictured is Bean's "Helping Hands")

It's a complicated and unscientific process. Often a publisher will consult with galleries to get a read on the excitement and response. The publisher might also look at the sales history of similar subjects and colors, sizes and shapes released by the artist and even other artists. It's a burdensome process with no definitive right or wrong answer. It's always a risk—and an important business decision.

Release Prices and Edition Sizes

The release prices, edition sizes, and the timing of the issuing of the releases are decisions normally made by the publisher. Because these items can directly affect the artist's career and collectibility, most publishers take the time to study the history of previous releases by the artist and similar print releases by other artists. In some cases they may also poll representing galleries, before making a final decision.

As with all retail products, the average price of offset lithographs continues to rise as a result of inflation. But the primary reason prices and the edition sizes of offset lithographs have adjusted upward is because of certain artists becoming more sought-after in the marketplace.

The average release price for a full-size (sofa-size) offset lithograph is $125 to $350 per print, while the release price for smaller images (e.g. 8" x 10") is usually between $50 to $125. The standard edition size of all limited edition offset lithographs is 1000 prints, though it's not uncommon to see editions done with as few as 300 prints or as many as 10,000.

Twenty years ago, while the offset lithographic industry was in its infancy, prices averaged about half of what they are today. As the industry

Carl Brenders is one of today's most collected offset lithographic print artists. (Pictured is Brenders' "Mother of Pearls")

grew, and publishers realized that potential for collectibility was the primary reason the public was responding, they lowered the edition sizes to numbers that ensured customer security. Now with the increased amount of collectors in the marketplace for offset lithographs, the edition size numbers are inching higher and higher.

The decisions the publishers make are based on what their instincts tell them the demand will be for a particular piece of art. The publisher's goal is to make the edition small enough and the price reasonable enough so the piece will receive a good response. But as with any other business, the intent is to make money — as much as possible both in the short term and the long run. The goal is to make it affordable for the collector and profitable for the seller. It is anything but an exact science.

The Tradition of Multiple-Sized Prints

They say size counts and who are we to argue? For the first 25 years of the limited edition offset lithograph, the publishers and artists seemed content to take a one-size-fits-all philosophy. If the decision was to print the image in a certain-sized format, then that was the only way it was offered. So, let's assume that you had a particular spot — over the sofa, perhaps — where you wanted the print displayed. But, the print you fell in love with was only produced as a tiny 5" x 7". What can you do? You can use the print as part of a grouping or put two feet of matting on each side (even though that would look ridiculous). In the past, you didn't have other options available. But that was then and this is now.

Today, it is acceptable to produce a limited edition in more than one size as long as it's announced and made clear to the consumers (preferably on the print's authentication papers) prior to the print's release. Producing a print in multiple sizes — sometimes as many as three: one small, one medium and one large — affords the collector a choice. What size proportionately suits their wall space?

Using multiple sizes makes perfect sense. We can expect methods to evolve over the next few years that will make it easy to identify prints made in multiple sizes. One way to number multiple-sized prints is to use roman numerals next to the numbering. For example: I/III — xx/yy; II/III — xx/yy; III/III — xx/yy. This way, regardless of what print the consumer sees, they can discern that there are three individually and consecutively numbered editions of the image on the market.

The bottom line is that multiple sizes are a good thing as long as the consumers are educated as to the breakdown of the edition before they are asked to make their purchase.

Image Sizes

The ideal print reproduction is one that comes as close to an exact copy of an original painting as is humanly possible. The colors should be as broad in spectrum and with similar intensity. The textures and layering of the paint should be apparent to the viewer's eye. The magnitude of the print should replicate the vision that the artist had when they swirled the colors of paint onto the canvas and masterfully executed a story, a thought or an expression. That's the goal of every print that goes into reproduction — to make the copy look like the original. However, there are intangibles that publishers must weigh and adjust to create products that are not only beautiful aesthetically but practical as well.

The one area that printers and publishers are forced to adjust is size. None of us will argue that it's tremendously impressive to walk through an art museum and view the monstrous works of the masters. Some measure six, eight or even 10 feet wide, with height proportions to match. But, most consumers could never find the space to squeeze one of those paintings in their homes. And, many of today's contemporary art masters paint with the same zealous pride as their predecessors, leaving publishers no choice but to adjust the size to fit the marketplace.

Of course, there are limitations to the paper size that most printing presses can handle as well. But, that rarely becomes an issue. The issue that publishers must continue to address is, how big can they make a print with the mass market in mind?

The publisher must consider things like the difficulty and cost of framing a large print, the economics of what price would be necessitated by an oversized image, and the overall impracticality of a print that's too big for over the sofa, the mantle and the bed. For these reasons, publishers are often forced to create art reproductions smaller than the artist painted their original painting.

Robert Laessig is not only well-respected by offset lithographic art collectors, but President Johnson used Laessig's paintings for his official White House Christmas Cards every year. (Pictured is Laessig's "Woodland Garden")

When a print is made smaller, the colors are brought closer together. In most situations this makes the print appear slightly more detailed to the eye, when in reality it may be adding more contrast and actually losing detail. Conversely, smaller paintings are almost never made bigger. A painting is a series of colors and brushstrokes and when a painting is made bigger, the colors and brushstrokes are spread apart causing loss of detail.

The goal is always creating a reproduction that as closely as possible replicates the original art. However, the size of the prints will continue to be determined by the marketplace's demands and options. Until an art-enthusiastic architect figures out how to build an attractive home free of windows, doorways and ceilings, size will continue to be an important factor.

The Ethics of Reprinting a Limited Edition Print

Ethics aside, the tradition in the art world has always been that a limited edition should not be reissued after the limited edition sells out. But, the tradition has allowed for posters and open edition prints to be issued as long as they are distinctly different in appearance and unlikely to cause confusion.

Thomas Kinkade's "Lamplight Lane" is available as a limited edition print and an open-edition Classic Edition print.

Recent trends in the art world have stretched the tradition to new limits. Limited edition prints have been reissued as smaller, open edition prints. Posters have been produced in sizes comparable to the limited editions of the same. However, because these editions are not signed or numbered, the public has been asked to accept them, and in most cases they have without argument.

Ethically, the best way to deal with potential confusion is for publishers to state on the authenticity that open editions or posters may be issued at a later time. This way the collector knows from the beginning that there may be other versions on the market and they can make their buying decision knowing the facts. Furthermore, on the authentication it should say that the artist will not sign any open edition print on the image, and the publisher should forbid the artist contractually from doing so. This would help eliminate any consumer confusion.

The Printing Process Takes Time

If you're the impatient type and you want everything yesterday, then you shouldn't be in the offset art publishing business. From the moment the painting is finished, it can take months before all the dots are spotted and the T's are crossed.

The greatest amount of time is spent preparing the plates, running proofs, getting approvals, making corrections, running more proofs, getting more approvals and on and on until the piece meets the dutiful standards of the artist, publisher and printer. In most cases, the process is considered fast if it gets done in six weeks. Realistically, it will normally take 60 to 90 days.

Two Different Breeds: Publishers and Printers

There's a difference between an art publisher and a printer, though many collectors assume that they are one in the same. In the world of offset lithography, no major publishing house does their own printing. They rely on printing houses that have skilled technicians and high-quality machinery.

The main reason is economics. The cost of a small single color press capable of doing high-enough quality work might cost $100,000 to $250,000. The single color press can provide excellent quality work. In fact, with a single color press each color is applied individually and given a chance to dry while the press is re-inked for the next color and all subsequent colors. As each color dries, it provides a base layer that future color applications can rest upon instead of being soaked into the paper. The result is often a strong, brilliantly colored print. However, the labor necessary to accurately pass a print through a printing press multiple times is very expensive, so most printers rely on four-color presses capable of applying four colors per application.

Four-color presses can cost anywhere from $1,000,000 to $2,000,000. For that type of investment the press must be run practically 24 hours a day or the cost can never be amortized over a reasonable amount of time. Even the most aggressive art publishers might only release 10 or 15 new prints a month. So the press would only be kept busy for just a few days a week.

Most printers capable of doing high-quality offset lithographic reproductions make their living doing periodicals, brochures and other full-color printed items. The art prints are just a small part of their businesses. They have teams of 10 to 20 people working on each project — cameramen, plate makers, printing technicians, etc. — which means the cost of the labor alone makes it unrealistic for any fine art publisher to consider doing their prints in-house.

The large publishing houses of today generally use more than one printing house, preferring to keep their "eggs in more than one basket." Since printers are supported more from other venues than the art world, they can't always meet the time demands that are critical to the art business. Furthermore, the risks associated with having so much riding on one printer are tremendous. What if a printer decided to close shop, stop doing art prints or even experienced a fire or other tragedy that put them out of business for a period of time. Then the publisher could find their business in trouble as well.

7

Limited Edition Offset Print Terminology

The Limited Edition Concept

Art can serve a solely decorative purpose. It can highlight a room, or bring satisfaction to its owners simply by its presence. But, art also has the potential to become a lucrative investment. And how does it become a lucrative investment? By giving collectors a product that has the potential to become rare. This is done simply by limiting the number of pieces available, guaranteeing that limit and providing the consumer evidence of it by sequentially numbering the images.

When you have an original work of art, you have a limited edition. Be it an edition of one, but a limited edition nonetheless. And that's why an original work of art can be a very sought-after commodity. If someone else wants it, they can't get it anywhere else. They can only obtain it from one source — you, the owner. With a printed reproduction of an original, as long as there's a limit to the number that are produced then there's the potential of rarity and subsequent collectibility, the same as with an original painting. The only difference in collectibility between a print and an original is the number of people who have the opportunity to experience the rarity.

So, why have limited editions? To spur collectibility and make ownership more fun for those who have the desire to participate. And, as with any collectible industry (baseball cards, Disney videos, or even certain luxury automobiles for instance), the thought of potential rarity forces faster decision-making, which, in turn, drives the marketplace. Without the limited edition concept, art prints might simply be valued at the cost of materials and production. By having the guarantee of quantity limits, collectors have the impetus to purchase now before every piece of the edition is sold. This can lead to price increases based on demand and availability. By issuing art in limited editions, the marketplace differentiates it as a collectible and not simply decorative art.

The numbers indicate that this is print Number 165 out of an edition of 950.

Breaking the Edition Down By the Numbers

Most limited edition prints are numbered in a standard format that indicates the edition size and the individual print's serial number within the edition. The numbers are normally found in the format "x/y" with "y" denoting the edition size and with "x" denoting the sequentially numbered print that the piece represents.

For example, if on a print you find the numbers 263/950, you can deduce that there were 950 numbered prints within the edition and that this particular print is the 263rd.

The numbers are normally found on the border of the print or near the bottom of the image. In some rarer cases, the numbers are found on the back of the image or are merely noted on the authentication paperwork.

This print is publisher's proof Number 14 of an edition of only 20.

The Artist Proof

The detail of original prints can vary depending on their place within an edition. As original prints are made, artists traditionally have personally selected the prints with the highest quality and denoted them "artist proofs" (abbreviated A/P). As original print editions are made, the plates used to make them tend to wear down, causing the latter prints of the edition to have less detail. For this reason, it is common for artists to simply designate the first 10 percent of an edition as the artist proofs. For some collectors, this means that the artist proofs are likely to be the best of the edition and therefore worth the most money.

With offset lithography, the plates used to reproduce the edition do not lose detail for an infinite amount of time. Therefore, each piece within the edition is of exactly the same quality. However, possibly because of tradition, artist proofs remain a part of most editions whether they truly are the first prints made or not.

The Publisher's Proof

A publisher's proof is basically the same as an artist proof except that there are even fewer of them produced. The original intention of publisher's proofs was to use them as gifts from the artist and publisher or as dona-

tions, and until recently, their purpose wasn't to be sold. But, soon it became another way to expand editions by creating another special section that might have more value to a collector who prefers to own a specially numbered print from within an edition.

Publisher's proofs usually sell for the same price as the artist's proof. Traditionally, publisher's proof edition sizes are very small — usually 20 prints or fewer. They are usually numbered in the same format as the artist's proof, but rarely abbreviated with their initials (P/P) like artist's proofs are (A/P). The thinking is that the initials, when spoken, "pee pee," are inappropriate talk for adults, and are more suited for young children learning to be potty-trained. For this reason the words "publisher's proof" are normally written out in long hand.

Today, publisher's proofs are rarely issued. The offset print industry, perhaps in an effort to clean up the legitimacy of their editions and make them less confusing, has gone primarily to artist proofs and regularly numbered prints.

The Printer's Proof

Another tradition in the art of offset lithography is to produce two printer's proofs. These are most often the property of the printer and can be sold. They are treated in a similar fashion to a publisher's proof or an artist's proof, they're just more exclusive and limited.

The Specimen Print

Specimen prints, otherwise known as sample prints, are often made available for gallery display purposes only. They are never supposed to be sold. Usually, the images are scarred with perforated type, printed lettering, or a publisher's logo and they are easily identified. With special editions — such as time-limited print editions — it is common for the publisher to provide each gallery with a specimen print to be displayed for collector viewing during the ordering period.

The Conservation Edition

Primarily brought on by the resurgence of our country's awareness of conservation issues, conservation editions are occasionally created to raise funds for non-profit organizations. These editions are generally seen with wildlife art exclusively, and the beneficiaries are organizations like The World Wildlife Fund or the National Wildlife Federation.

Conservation editions are generally smaller in edition size than the regular edition of the same print — often fewer than 200 prints. Occasionally they sell for a premium, but most of the time they are offered for the same price as the regular edition. They are printed with exactly the same image size and with the same quality replication as the main edition. The prints are generally donated or sold to conservation organizations for exclusive sale and profit making. Conservation organizations market these

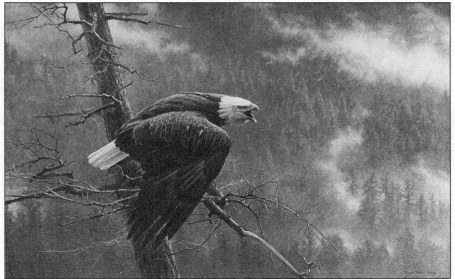

Robert Bateman's "The Air, the Forest and the Watch" was a very successful time-limited edition.

editions to their members through direct mail catalogs and benefit auctions, to raise money to fund their related causes.

Conservation editions are normally signed and numbered just like other prints from within the edition. The only difference is the addition of the words "conservation edition" or the symbol "C/E" found immediately after the numerical designation.

The Time-Limited Edition Concept

If the edition size of a limited edition print is decided by the artist and/or respective publisher, then a time-limited (commission print) print's edition size is decided on by the collectors.

The procedure to determine the edition size of a time-limited print begins when collectors are advised of a new image scheduled to be released in the future by an artist and/or publisher. The collectors are given a set amount of time to place their orders for the print — often 30 to 90 days. When the time frame expires, the ordering opportunity is halted. The orders are tallied and the edition size is set. Each print is then numbered as with any limited edition print.

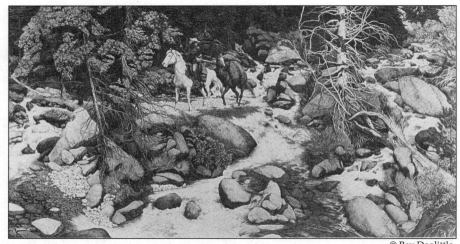

© Bev Doolittle

Even though it was issued for only $175, today Bev Doolittle's time-limited print "The Forest Has Eyes" trades for over $5,000.

Occasionally a publisher will number each print consecutively as the orders are received. In these rare cases the numbering does not indicate the total of the entire edition. In other words, the designation for these prints is simply "x" instead of the usual "x/y" designation. The "x" represents the print's sequential place within the ordering process.

Some collectors shy away from time-limited editions because they feel that the time-limited print is merely an open-edition print with numbers. But that's simply not true. It is an opportunity for collectors to own an exceptional work of art that would likely sell out too quickly if it was done in the traditional way. If the print were released in the more traditional way, the piece would likely have to be priced at an extremely high amount to offset the demand it would inspire.

Consider camouflage artist Bev Doolittle. Doolittle has done numerous time-limited editions in conjunction with her publisher, The Greenwich Workshop. The edition sizes have varied between as low as a few thousand to as high as almost 70,000 copies. And, even with the extensive size of Doolittle's time-limited editions, most of the prints have seen strong resale demand. Why? The market for Bev Doolittle's art is large enough and strong enough to support such a venture.

Furthermore, Bev Doolittle's history shows that after one of her time-limited editions is released, there is collector demand and investment potential. The demand seems to snowball as more and more people dis-

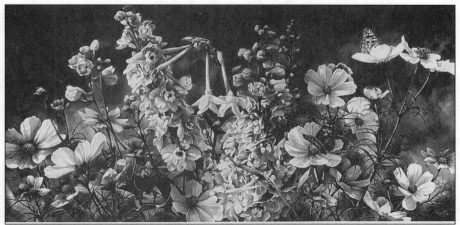

The warmth of a floral landscape is exhibited in "Garden Party," painted by award-winning watercolorist Arleta Pech.

cover her work and that creates even more interest and more collectibility for the time-limited images as well as future images.

The key to a time-limited print's success has to be traced to the same qualities used to determine whether a regular limited edition print will be successful. Is it a strong image, by a strong artist and would people like to own it? If the answer is yes, then there is a strong possibility that even after the ordering period has ceased, that collectors will still desire the image and the collectibility can still be generated if the supply is less than the demand.

The Open-Edition Print Concept

Cardigan sweaters, books about offset lithographs, and your favorite place to eat dinner: what do they have in common? The designers, the writers and the cooks have the option of continuing to produce their product as long as the public demands it. Open-edition prints are no different.

Simply, an open-edition print is any piece of art that is not limited to a specific number of reproductions. Most posters would qualify as open-edition prints. The Farrah Fawcett pinup poster, the promotional movie poster for "Raiders of the Lost Ark" and the poster that commemorates the art show that Robert Bateman had at your favorite art gallery are all examples. Also, all the reproductions of famous museum paintings by Van Gogh, Monet and others are considered open-edition pieces.

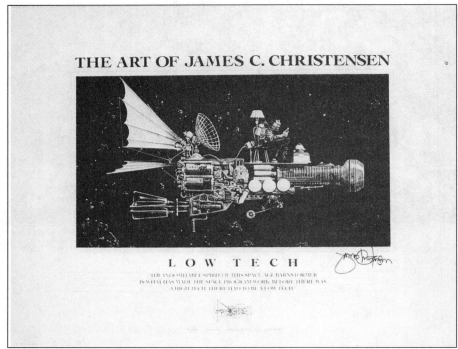

THE ART OF JAMES C. CHRISTENSEN

L O W T E C H

© James C. Christensen

This poster by James C. Christensen is anything but "Low Tech."

The publisher of an open-edition piece has the ability to print 5,000 pieces, then follow with another thousand, and another, as many times as they wish, for as long as they desire. In other words, as long as the publisher feels the print serves a purpose, either financially or promotionally, they have the option of producing more copies.

Those who purchase open-edition pieces should do so merely for decoration. Since there is no limit to the amount that could be made, open-edition prints will rarely increase in value. It takes a lack of supply to force demand. If there is demand, the publisher will most likely print more. If for some reason the publisher decides not to print additional pieces, then the open-edition print has the possibility of increasing in value, but there is no guarantee that the publisher wouldn't change their mind. And, unless the publisher publicly announces an intention to stop production permanently, then the decision to reprint at a later time remains a risk and it is completely ethical.

Be cautious if you decide to buy an open-edition print if your desire is to own a collectible. Since there are no guarantees, they should be purchased for their decorative value and not as an investment.

The Poster Concept

A poster is an open-edition reproduction produced to advertise, promote or commemorate an event, a show or an artist. The main difference between a poster and a standard open edition is the poster's promotional make-up. They usually include the artist's name and other pertinent information — for instance, the name of a gallery or publisher and the dates of a showing. With a poster, the writing is part of the design and it's meant to be exposed when the piece is framed.

Most posters sell for between $10 and $50, are often printed on less expensive paper than a traditional open-edition print, and they often lack the superior print quality associated with a fine art offset print.

In rare instances a poster might be produced in a limited edition format. When this is done the piece is numbered in the traditional way that a limited edition is numbered. And it is not uncommon for a poster to be signed by the artist.

What Does e.a. Mean?

Epreuve d'artiste, also designated "e.a.," is the European translation of artist proof. Though it is primarily used on European editions, American publishers occasionally use "e.a" as well.

Hors de Commerce

"Hors de commerce" or "H/C" is a designation placed on the border of a print, the same way as artist's proof is denoted on a print image. The phrase is translated "out of commerce" and is often seen with European prints. In America the designation is interpreted as "house copy" and it is very rarely used. Prints with this designation are not intended for sale and are often used for promotional purposes only. When they are sold, they are valued much the same as an artist's proof.

Remarques

A remarque is an artist's original drawing that is added to a limited edition print. The remarque is normally found in the border below the image and can be as simple as a pencil drawing or as elaborate as a completed miniature painting. Normally the remarque represents a detail from the print. Standard remarques are in pencil; however, it's not uncommon to see color remarques painted or drawn with colored pencil or watercolors.

For many collectors the remarque is an inexpensive way to own an original painting. Others just enjoy knowing that the artist has added a personal touch to their picture to make it different from the rest of the prints in the edition.

THE SIDE-WHEEL STEAMBOAT *T. V. ARROW*
BY JOH

Morning

John Barber's detailed pencil remarques bring additional value for his collectors.

The price of remarques can vary tremendously depending on the stature of the artist. For example, maritime artist John Stobart's very elaborate pencil remarques can add $1,000 or more to the price of the print, while other artists might just do a simple remarque for $100. Every artist does it differently. Perhaps that's part of the mystique that makes remarques so special.

The Signature

The Purpose of the Artist's Signature

The artist's signature is the collector's guarantee that the artist has looked at the print and verified its authenticity and its quality. However, the collectible value of the print is not in the autograph. The value is in the quality of the reproduction and the limited edition format that offers the potential of rarity.

Most artists sign their works in a mechanized fashion, with a helper that pulls the prints, one by one. A stack of prints 2 or 3 inches high is prepared on a desk. The artist sits with a pencil in hand at the spot that coincides with the position where he intends to sign, and the person pulling sits or stands across the desk and moves the prints one by one to a second stack out of harm's way. The artist signs a print, lifts their hand at the wrist, the helper pulls the print away, the artist drops their hand in the same position and the process repeats. The process happens so quickly that the artist hardly has time to even take their eyes off the pencil.

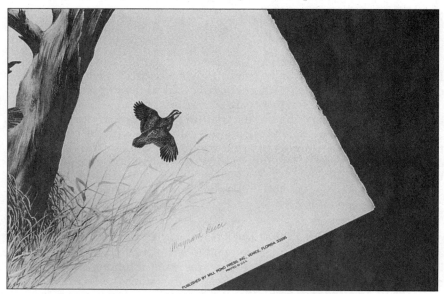

The artist's signature has become a standard feature of offset lithographic prints.

© Carl Brenders

Carl Brenders' self portrait shows that the signing process does allow for opportunities to relax.

In reality, the artist isn't looking for any imperfections in quality. Imperfect prints will be caught later during an inspection when the print is either put in its protective sleeve or simply packed for shipping.

The main reason that prints are signed is tradition. Artists are just doing their job and carrying out the tradition of artists that preceded them.

The key element in determining the value rests with the concept that there is a limit to the number of prints produced. Think of the signature as an autograph. A print has slightly more value with an original autograph than without it, but without it, it will maintain its value as long as it is an authentic reproduction and all the prints within the edition are either signed or unsigned the same way.

The Laborious Signing Process

Remember the days when you had to write one hundred times on the blackboard after school, "I won't throw spit wads at Johnny" or "I will do my homework on time?" Do you remember the pain? The "writer's cramp"? Well, now you know what it can sometimes feel like to be a limited

edition print artist. It's not all paint fumes and creativity. It's sometimes monotonous and painful. But, the signature is a tradition in the world of art and unless an artist specifically states that they won't be signing an edition, you can bet your bottom dollar that they probably will.

The way artists sign their prints is really up to them. Some use their full names, while others just use their last name. Some scribble their signature to the point that it's illegible, while others take the time to keep it clean and recognizable. It's simply a matter of preference, though it's best when the artist stays consistent. When an artist sometimes signs with their first and last name, and other times with just their last, the public can find reasons for prints that are exactly the same in quality to differ in value. When the artist stays consistent, it eliminates the potential for problems.

Most standard editions today are about 1,000 prints. The time it takes to sign that many copies can range from a few hours to a couple of days depending on the artist. Obviously the length of the name can play a part in the time equation, but the real difference is the amount of breaks and socializing the artist does during the signing process.

The largest-known limited edition print ever run was Bev Doolittle's 1989 release "Sacred Ground." This time-limited edition was capped at 69,996 prints, and Bev Doolittle really did sign them all. Reportedly it took her over one month to accomplish the task. Some might say that's a small price to pay considering the print raised over $18.5 million for the art community.

Of today's leading offset artists, there are only a couple of artists that don't actually hand-sign their prints. One of the artists is Thomas Kinkade who has gone to a double-referencing authorization system. This system uses an auto-pen technology, similar to the way the President of the United States signs and a special ink that is created directly from the artist's DNA. The authenticity of the signature can theoretically be determined within seconds with the use of a special sensor, which eliminates any question about authentication and legitimacy.

To date, there are very few cases of forged signatures. With the industry only about 30 years old, most of the artists are still alive and active, and they can act as the official authenticators should a question arise. However, as the industry grows and artists pass on, the potential for problems will grow as well. Systems like the one used by Kinkade may very well become the norm, and artists will have to spend less time going through the grueling hand-signing ritual. They'll be able to spend more time bringing collectors creative and exciting works of art.

Locating the Signature

For years, the tradition in the art world has been for artists to hand-sign their prints on the border just below the image. However, some artists and publishers prefer that their artists sign within the image area for aesthetic reasons.

The stack on the left gives an indication of how many prints Robert Bateman will be signing. (Photo courtesy of Mill Pond Press)

When the artist signs on the border, it is generally done in a space that doesn't exceed 1/2 inch below the image and normally, the signature is found on the same side as the plate signature. When the print is matted, the framer will then show an equal amount of the white margin on all four sides.

Sometimes the traditional pencil signature doesn't show up well when it's placed within the image area, especially if the image is dark, and in those cases either a colored pencil or gold or silver pen is often used.

The placement of the signature has nothing to do with the value of the print. It's purely a preference of the artist and publisher, though the scuttle-butt in the industry is that the white margin can cause an image to lose some of its impact. So, there's a movement today for more and more prints to be signed within the image.

The Pencil Signature

In school we're led to believe that using a pencil is a temporary and informal way to write, but in the art world using a pencil has been the traditional way to sign prints for generations. Why? Because a standard graphite pencil will last infinitely unless it's erased, while a fountain pen or a marking pen — even permanent ones — will eventually bleach out and disappear.

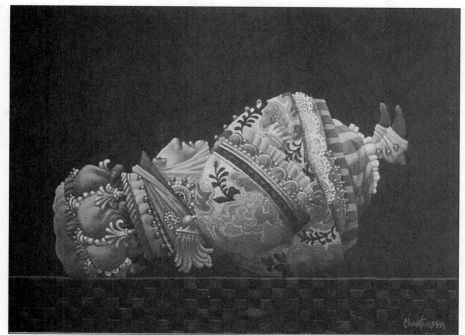

Sometimes the title can tell the story as it does in this print by James C. Christnesen titled: "Even as he stopped wobbling, Wendall realized that he had a dilemma."

Since the pencil lead is charcoal gray, it shows up very well on the white border of a print, but in cases where the prints are signed in the image, the gray can be nearly unreadable. In these isolated cases colored pencil is sometimes used or a real gold leaf or silver leaf pen. These methods will also last infinitely, though the color pigment in the pencil can bleach out through time and the gold and silver leaf can tarnish.

The Signature and Investment Potential

To the artist, publisher and the gallery owner, the only signature that is important is the one that the collector puts on their check. To the collector the most important signature is the one that graces a prized limited edition offset lithograph.

Overall, an artist's signature on a limited edition print is merely an autograph. Its value is truly nominal. The real investment value is dictated by the guarantee of limited production and the numbering that guarantees for the collector that no other prints will be produced when the edition is sold-out.

Two Signatures Per Print

Trivia question: How many times does Robert Bateman sign each of his limited editions? Once, twice, three times, or all of the above. Take your time, you have 30 seconds. Tick-tock, tick-tock. I'm sorry, your time is up. The answer is twice.

Did you ever notice that nearly every hand-signed print is signed not once, but twice? Take a look next time and you'll see. There is the pencil signature applied to the print after the print is made. This is what is being referred to when they use the word "signed and numbered." It is an original "John Hancock." It can be found either just below the image in the border, or within the image, usually near the bottom.

But there's also the second signature and that's the plate signature applied by the artist when the original painting is complete. This signature shows up again when the print is reproduced. It is not an original and it offers no additional value. It is simply a reproduction of the original signature just as the image is a reproduction of the original painting.

If you look closely you'll also see how most artists display a different signature for each purpose. Often the painted signature looks like it was done with a brush and is in block or printed lettering, while the original signature appears more like an autograph.

The Plate Signature vs. the Original Signature

Ask any artist what parts of the painting process they look forward to the most and they'll say the beginning and the end. The beginning because it's the time that they can let their creative juices flow and see their conceptual design come to life. And the end, because that's the moment that they can cross the T's and dot the I's, and revel in a job well done. All the painting in between is just work. If the painting is to become a print, then that final dotting of the I's is where the artist applies their plate or stone signature.

A plate or stone signature is the signature that the artist places directly on the original painting, not on the print. When the print is reproduced, the signature is reproduced as well, but it is not considered an original signature. It is a copy of the original signature.

The original signature is the one applied in pencil, in the margin or on the image of the completed print. In the art world, when one hears that a print is signed, it is meant to imply that the piece does have an original hand-applied signature. In other words, the artist has autographed the paper, acknowledging that it's their work, they approve of its appearance and they guarantee its authenticity.

It is more common than we'd like to think that dealers use the stone signature as a selling tool, which invariably confuses the collector. The plate signature brings no additional value to a print. All prints have it unless the artist perchance forgot to sign the original painting.

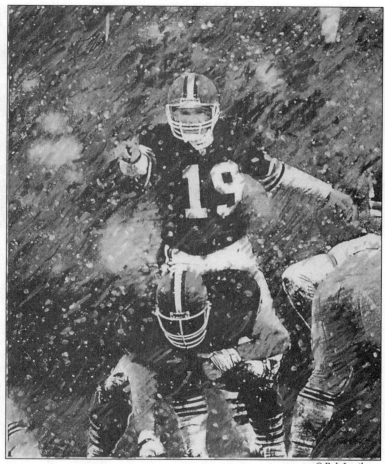

"The Audible" by Bob Leathers not only pictures former Cleveland Browns player Bernie Kosar, but Kosar also hand-signed each print from the edition.

The Value of a Countersignature

What is the value of an autograph? Occasionally a print will be released with someone else's signature besides the artist. The signature might be from a celebrity, a sports figure, a well-known environmentalist or a famous aviator or astronaut. In the past, we've seen Jim Fowler of "Mutual of Omaha's Wild Kingdom" lend his signature to print; and Tom Hanks and Kevin Bacon from the movie "Apollo 13," participate by signing a print about the famous mission. We've also seen a number of athletes — Muhammad Ali, Bart Starr, Jim Brown and others — join forces with a piece of art to create a package of unique collectibility.

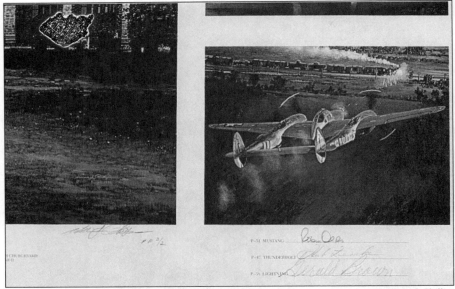

William S. Phillips' aviation prints traditionally are countersigned by decorated military veterans.

Normally, the signer will have obvious ties to the imagery, as is the case with an athlete depicted by an artist and then countersigned by the player as well; or an aviator that signs a print that features the plane he flew in a historical mission. However, Gerald Ford signed a wolf print to offer interest and support to an environmental cause that he supported.

The purpose of the signature is to create additional interest from people who aren't traditional art collectors — aviation buffs, sports fanatics and the like. By bringing these folks into the marketplace, additional demand is created for the release and more people are exposed to the excitement of art collecting.

From a resale standpoint, if the collectibility of the print is focused on the world of art, then the art must stand on its own without the signatures. If the art is good, then the signature is a valuable bonus. But, if the art is weak and the collectibility is targeted towards autograph hounds, then the signature had better be able to drive the interest alone. Ideally both the art and the signature will be strong, in which case an exciting package is created and the opportunity for strong collectibility is established.

9

The Secondary Market

Finding the Secondary Market

Despite popular opinion, the secondary market isn't as defined as the markets of Wall Street. It's merely the name used to describe the various sources where old and rare collectibles can be found. A piece is considered on the secondary market when it's sold-out from its main source. In the art world this is when the publisher who initially issued the print has no more to sell.

Art galleries, art brokers and art collectors make up the secondary art market, as well as pawn shops, estate sales and antique shops. It's an all-encompassing term that represents all the possible sources for locating a sold-out print.

When a print is said to be on the secondary market, the natural assumption is that the print can only be obtained for a price higher than the initial release price. But that isn't always so. There's often a period when the print is sold-out by the publisher, but dealers may still have the work in inventory. And, there will always be sold-out prints that collectors don't have a high demand for and prints that will become available for the issue price because their demand has declined.

Consider the process that exemplifies the secondary market's role and function. Initially, a print is available from a publisher who sells it to the various authorized retail outlets. Then the retail outlets sell their inventory of prints to the consumers. If the publisher runs out of the print and a retailer needs a copy of the print to fill a consumer request, where do they turn? They turn to the secondary market.

In today's sophisticated world, there are computer networks, magazines and newspapers that list prints available for sale. All a dealer needs to tap into the secondary market for art is a phone or a mouse. It's really that simple.

The Primary Market Defined

If the secondary market refers to the market used to obtain a sold-out edition, then the primary market refers to the market used to obtain an edition that is not sold-out. The primary market is made up of the publishers, artists and galleries that offer prints for sale before they are sold-out, but the terminology is based on the publisher's availability. When the publisher is sold-out of the print, then it is considered a part of the second-

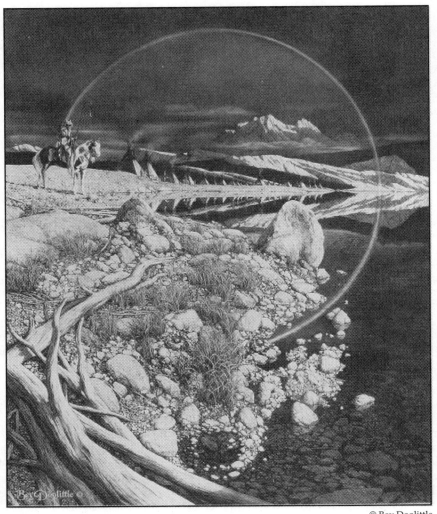

Bev Doolittle's "The Sentinel" shows her trademark ability to tell a story through camouflage art.

ary market, since the only way to obtain another copy is through secondary sources.

The primary market most often offers prints at the issue price, however occasionally a print will be issued with a pre-publication price that is better than the standard recommended price. And, other times the publisher may adjust the price after a certain percentage of the edition has been sold. In either case, the print is still considered to be on the primary market because it's available from the primary source — the publisher.

A good art book can help collectors find out more about what inspires the artist to paint a certain image. (Pictured is Stephen Lyman's book "Into the Wilderness: An Artist's Journey")

Determining the Secondary Market Price

In a true secondary market the price is a direct reflection of the supply and demand as it affects the collector. The price is determined by a "meeting of the minds" between the owner of a print and the collector who wants it.

If the scenario were scripted perfectly, every time a collector had a print they wanted to sell, they'd arrange an auction with every potential buyer in attendance. Whatever price was paid would be the current secondary price. Unfortunately it's not quite that simple, but it's not too far off.

Today's art dealer has the ability to view computer-generated listings from other dealers around the globe that show the prices that collectors are willing to accept for their art. The collector will always want as much as possible, while the buyer will always want to pay as little as possible. By using this type of listing service in conjunction with a dealer's own listings, the dealer can determine the lowest priced print of an image that is available. Then by adding on a commission for their efforts, the dealer can determine a secondary market price. No one can guarantee that somewhere else in the world the print isn't available for a lower price. But, this system is the one that most dealers and collectors follow.

Secondary Market Sources

During the past few years, companies have arisen whose main intent is to match up buyers and sellers on the secondary market. These companies provide dealers with listings of consumers, retailers and brokers throughout the country who are interested in selling works of art.

The listings are based on information provided by the seller, such as their asking price and the condition of the work. By using such a list, galleries are able to quickly see what it would cost to obtain a work of art, then by adding their markup, determine the secondary market price within just a few minutes.

One such company is The Art Expediter, which provides their secondary market service in a newspaper format, issued monthly. Another service, Art Information, is an on-line computer service updated daily. Both of these services, as well as most of the other similar services, cater strictly to the dealer market. Clients interested in selling a work must work through a gallery, who in turn will list the work on the customer's behalf. Neither service charges for individual sales and neither handle the transactions. They both make their money from subscriptions and listings.

Even though these systems make locating works on the secondary market easy for art dealers, many galleries use these services in addition to their own client base to locate sold-out works of art. By using their own base, a gallery can normally avoid shipping costs and be more assured that the condition is as represented. But, most of all, by using their own client base, galleries are able to reward clients who exhibit loyalty to them.

The Art Brokers

Most art brokers are simply collectors who buy and re-sell prints as a hobby. They purchase the hottest prints from galleries throughout the country, then when the price escalates because of the demand they sell the pieces at a profit. The broker is actually quite dangerous to the marketplace yet irreplaceable at the same time.

If a print is released that the brokers throughout the country buy a lot of, they'll cause demand for the work due to lack of dealer supply and in some instances cause a panic. What tends to happen in these instances is the newly released print will skyrocket in price very quickly, but when the panic ends the market price will come back down to a more realistic value. The loser in this scenario ends up being the collectors who bought the piece at the high side of the secondary market curve.

At the same time, brokers are very valuable to dealers and collectors. So many collectors who buy art have no interest in selling. All they want is an aesthetically pleasing work to decorate their home or office. And, these collectors rarely want to sell anything. So, when a collector or dealer wants to obtain a sold-out work, they have to rely on people willing to sell. And, the brokers are always willing.

In the world of offset art, there are a handful of well-known brokers. These people know how to inspect a print and how to pack it for shipping and they know that they have to offer their art at the best prices. Their reliability makes them a very valuable asset to the dealer network.

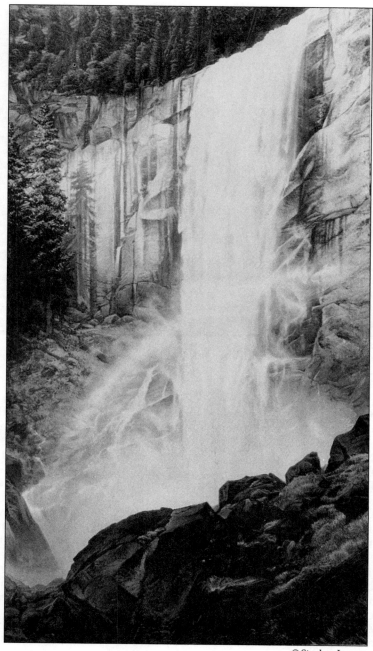

Stephen Lyman's use of light as shown in "Dance of Water and Light" made him one of the world's most collected artists.

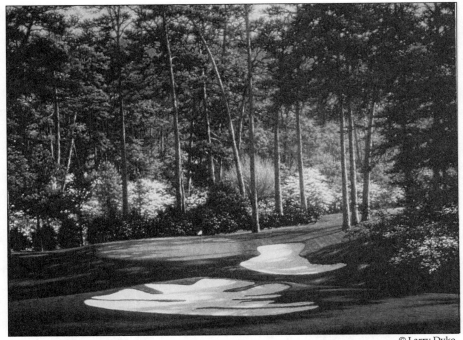

No matter what your interest is, the world of offset lithography has something for you. (Pictured is Larry Dyke's "The Tenth at Augusta")

Selling on the Secondary Market

Selling a work of art can be emotionally trying. But, often with fine art the financial reward can outweigh the distress. Maybe you need a few quick bucks, or maybe you need to clear a little wall space for that new masterpiece that you are drooling over. Regardless of the reason, the procedure is the same.

The first thing to do is determine the value of the work. The value is based on what a current collector wishing to obtain the piece would be willing to pay. There are magazines on the market that can give you some idea of value, and the gallery where the print was purchased or the publisher of the work can usually give some information as to the current market price. In some cases, the gallery or publisher that you contact may know of a collector or a gallery who is looking for the print or is active in the secondary market of that artist. If all else fails, the value is whatever the minimum price you, the owner, would be willing to accept either in a trade for products or dollars.

After determining the value, the next step is to put the piece of art on the market. You should decide whether you'd only be happy selling the work for its retail value, or if you could be satisfied selling the work through a gallery and accepting the wholesale value.

If you're one of the lucky ones you'll know who you plan to sell the work to, before even knowing the market price. More commonly though, you'll be on your own and might want to attempt to locate a retail buyer through the newspaper, possibly with a small classified ad. If the work is in high enough demand or the artist is well-known in the circulation area, your chances for making a sale will increase tremendously.

After running the ad for a week or two you should have some indication based on the responses what the chances are of selling the work on your own. Keep in mind that a knowledgeable collector will be concerned with condition and will want to know if the print was bought and framed by a reputable art gallery.

If you didn't succeed in selling the work on your own, don't fret. Select a gallery that you believe will be able to sell the work in a reasonable amount of time, be prepared to pay them a commission for their efforts, and put the piece on consignment.

Occasionally, a work of art will be difficult to sell due to the timing of the attempted resale. Perhaps, the economy might be in a decline, or the artist might not be in significant enough demand. Remember, as with any investment there are peak times to sell. You'll have better luck with an artist who is in his prime as opposed to one whose art is not as strongly sought-after.

Art is perhaps the greatest investment of all. Not because of the amount of profit that can be guaranteed upon its sale, but because of the amount of enjoyment that a beautiful piece of art can provide. And, even if the scenario dictates a loss of money — or what a stockbroker might call a bad investment — the owner of the art should never feel that they truly lost if they followed the first rule of collecting for investment: only buy what you like.

Standard Gallery Resale Commissions

Gallery commissions tend to vary from about 10 percent to as high as 50 percent of the selling price. The average commission across the country for reselling a work of art is about 33-1/3 percent.

If you feel serious about selling a work, then you'd be wise to concentrate on a gallery that has an established secondary market for the specific artist's work, and one that has a good reputation. Be careful not to be misled by a gallery who either doesn't represent the artist's secondary market or doesn't carry the artist's work at all. You need a gallery with a following for the artist. Chances are if they don't show the work on a regular basis, they won't have the client base necessary and they'll just be wasting your time. A reputable gallery who is active in the secondary market will know the industry's secondary market commission structure, and hopefully treat you fairly.

A gallery may also ask for a predetermined minimum amount of time to make the sale. Sometimes it can take time to find the buyer and often the potential buyer needs time to think before finalizing their decision. So, feel comfortable giving a gallery 60 or 90 days of exclusive selling time. And a

gallery may also want to inspect the work first or have it on display during the selling period. If you want to sell the print, let them inspect it and put it on display. You want it to be seen by the consumer and you don't want to rely on the salespeople to remember to talk about it. Give it a chance to sell itself and give the consumer a chance to see it and fall in love with it, the way that you did when you decided to own it.

Finally, remember that art galleries are in business to make money. If they are taking a commission on a sale of 33-1/3 percent, they have likely determined that they need that much to cover potential commissions, credit card charges, wall display, lighting and advertising. It's all part of the package. Furthermore, the larger the gallery commission, the harder you can expect them to work to sell your piece. Remember they want to make the profit, too. You want them to have an incentive.

Roger Tory Peterson (1908-1996) (Photo courtesy of Mill Pond Press)

10

Condition, Condition, Condition

Defining Mint Condition

Whether your interest is collecting baseball cards, Model T's or fine works of art, the condition always plays a part in determining the value. And, as with nearly all collectibles, one man's "mint" is another man's "mistake." So, what really constitutes a "mint condition" offset lithographic print?

The term "mint condition" as it relates to offset lithographic prints is intended to imply perfect, pristine condition. Is the print in the same condition as each and every print that was created at the same time? And, does it look the same as it originally did when it rolled off the printing press guides and gently fell onto the stack? Both of the questions must be answered with an emphatic "yes" or the print cannot be designated as "mint."

The problem with the term "mint condition" is that it is often used too loosely by collectors and even many gallery owners who don't know how to do a proper inspection. They often base their decision on trust, assumption and a quick one-two glance. They trust that the print they received was

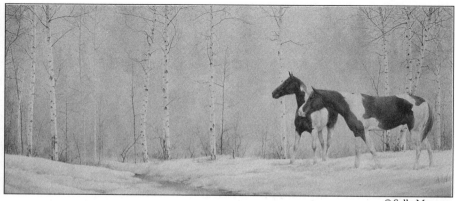

© Sally Murray

Artists sometimes find their inspirations right at home, as Sally Murray did when she painted her own horses in "Cold Snap."

"mint" in the first place; and they assume that nothing could have happened to the print while in their possession to have altered its condition. And, that's where collectors make their mistake.

A print must be inspected from the front as well as the back for bends and dirt. The borders, edges and corners need to be analyzed for wear and tear; and the printed image needs to be inspected for flaws. If there is any reason that another print from the same run exists or existed in better condition then the print in question cannot be represented as "mint."

The Importance of Condition

Assume that you are the owner of a print and you are interested in selling it. Ask yourself the question: "If there is a print of higher quality and better condition available on the market for the same price as my print, then which one will a potential buyer want?" All things being equal, the buyer will desire the one in the best condition.

Sometimes getting a perfect mint condition print isn't possible. Perhaps the print desired is extremely old and rare. Perhaps the only known prints in existence are in private collections or hanging on collector's walls. Perhaps after months of searching, the only print that can be located is not in the pristine condition desired, then what is the print worth? Then, it's worth whatever the seller is willing to accept and whatever the buyer is willing to pay. It then has less to do with condition and more to do with supply and demand. But, that's a rare instance today.

Today's print market is extremely sophisticated. There are on-line secondary market networks and trade journals with lists of prints for sale. In most cases a mint condition print can be located with time and some amount of effort. Therefore any print not deemed to be in mint condition is going to be worth less than one that is mint.

They say the value of a home or a piece of real estate is determined by the location, location, location. In the world of art, the value of a print is determined by condition, condition, condition. Condition is of the utmost importance.

Conducting an Inspection

Since the print must be handled and turned over during the inspection process, a collector unfamiliar with the process could actually do harm more than good. If possible, have a gallery representative or professional picture framer do the handling for you. If you decide to do it yourself, be very careful.

There are two things that you have to do before you ever begin. The first thing to do is arrange for a well-lit, clean, flat area to lay the print — a table for instance. Secondly, wash and dry your hands.

In most cases, the print will be in a folder or envelope and you can lay the entire package directly on the surface of the table. Carefully open the folder and remove any biography cards, authentication paperwork, buffer paper or other material that is laid on top of the print.

Knowing how to handle and inspect a work should never be taken lightly. (Photo by Alan Brown)

Without touching the print, look over the image for anything that looks out of place and might be considered a printer's flaw. Are there any scratches, dents or impressions in the image that look out of place? Is there any discoloration along the edges of the image, perhaps from exposure to light or from a previous mat or frame?

Next, look at the border and each of the corners of the paper. Is every corner clean and fresh in appearance? Are there any bends or tears? Look carefully, because often corner bends are missed during the initial inspection.

Then, pick up the print from the sides. Be extremely careful to hold the print completely flat. Move the print slowly up and down from side to side. Do you see any dents or dings? Is there anything else that now shows in the different light?

Now, you have to flip over the print. Be very careful. This is the step where damage occurs most easily. Stand so that you are positioned in front of the longest edge of the print. Then using both hands and as few fingers as possible, grab the print on the near edge with your hands spread as wide as possible, and carefully lift up the print. Then in one even motion, flip the print. If you flip the print and your motion is not equal, you'll likely put a ding(s) in the paper.

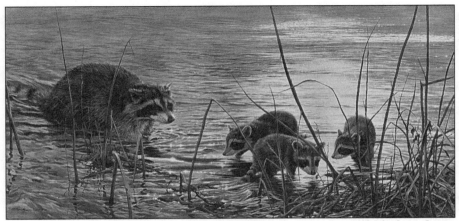

*John Seerey-Lester's ability to create a mood is evident in this image called "Moonlight Fisherman —
Raccoons."*

Now, look over the back of the print the same way you looked over
the front. Analyze the edges and corners again and use the light to look for
dents and dings that didn't show up from the front. In reality most dents
and dings are more visible from the back of a print because of the white of
the paper, so take your time and look very carefully.

Take a close look at the top edge on the backside of the print. Is there
any indication that the print might have been previously framed? Is tape
still on the paper? Or could there be a slight alteration of the paper fibers
where tape previously existed even though it has been removed? Most
often the marks from tape can be found in two places, each about one-third
of the way from each corner.

Finally, flip the print back over and measure the print. Hopefully you
have access to a brochure or catalog that indicates the paper size. Is the size
as represented? Is there any way that the print could have been trimmed?

If everything is clean and in order, then your print is probably in mint
condition. If you have any questions or concerns then get a second opinion.

Avoiding the Dings

It may not sound like a bell tolling, but nevertheless "dings" can take
their toll on a print. A ding is an impression in an art print from handling.
They often resemble the shape of a crescent moon and they can be easily
caused when a print is lifted or turned.

A ding can be minor — in which case the paper isn't truly broken, just
bent. In those cases, a professional can often remove the ding with a tiny bit
of distilled water and a warm iron. In more severe cases, the ding can break
the paper, creating a crease that is often impossible to remove.

Dings are a very common problem with prints. But, it's not just the

novice collector that causes them by foolishly handling pieces of unframed art. Dings are often caused by the professional handlers — artists, printers and galleries — and they can have an adverse affect on the condition and value of a print.

The Effects of Flawed Prints

Any imperfection in a print, whether it was caused by improper handling or was an oversight by the printer and/or the publisher of a work of art, can devalue it.

Most prints are checked for flaws by inspectors working for the printer and then again by inspectors working for the publisher before they are sent out to the gallery network for distribution. And, most reputable galleries will carefully inspect prints upon their receipt, before passing them on to their collectors. Still, occasionally printing flaws will make it completely through to the collector before they are noticed. For this reason, it is highly recommended that you examine your art carefully before accepting possession.

In cases where the print flaws are minor, and consistent with the entire edition, the full value of the artwork is normally maintained. The full value is held because there are no better quality works of the image on the market.

There have been instances where prints have been recalled, just like an automobile recall. For instance, one print released in the mid-1980s had a scratch that was hard to see because it was hidden by the pattern in a blanket on the primary character's lap. The publisher caught the flaw soon after the print was released, and notified the dealer network who in turn recalled the piece from the collectors who had already received it. It was reprinted.

Normally, by the time a work reaches the collector it has been examined and re-examined many times. But, since the ultimate responsibility is with the consumer, it is highly recommended that you inspect your prints very carefully. If you see something unusual, take the time and effort to question it. Most galleries, publishers and artists want you to have a perfect print and they'll help you to get it replaced without charge.

Roller Marks

Every offset print is made using an offset printing press, and every offset printing press grips the paper with rollers to keep it in place as it moves through the printing process. This gripping causes what are known as roller marks—small, one-inch by one-inch indentations on the border.

If the paper being used is big enough to allow a reasonable border around the image, then the marks are generally eliminated when the paper is trimmed after the printing is complete. However, occasionally with larger prints, there is very little trimming done and the roller marks can be seen upon close inspection. As long as these marks are consistent with every print within the edition they do not affect the value of the print. They are a necessary part of the offset printing process.

Robert Bateman's fourth book release "Robert Bateman: Natural Worlds" features insight into the artist, his images and his views on conservation.

The Border Condition

Even though it's generally covered by a mat and frame, the entire border of the print must be in perfect condition for the print to be considered in mint condition and of utmost value. The border is part of the design. Furthermore, because it's the area most often handled — and it's traditionally white or off-white — the border is often the first area of the print to show age and wear.

It comes back to the same basic question: If you have a choice of buying a print with an imperfect border or, for the same price, obtaining the same print with a perfect border, which one would you select? All things being equal you'd choose the perfect one. Therefore, the condition of the border can have a serious impact on value.

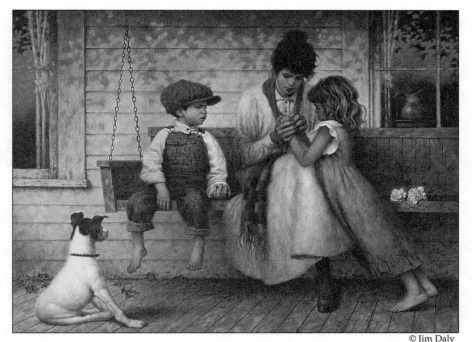

Jim Daly's ability to capture the interaction of family relationships helped make him one of the nation's leading artists. (Picturing is Daly's "The Thorn.")

Always be conscious of the border when buying a print. If you are buying a framed print from a gallery's display and because it's framed you can't inspect the border, take a look around the store. Look at the unframed art that they have out. How are they presenting it? Is it protected in a way that it can withstand reasonable handling? Do they show unframed art with bent corners, dirty borders or bent edges, then value it the same way they value mint prints? If they do, then there's a decent chance that the print you are looking at is valued the same way.

If you are concerned, it is appropriate when purchasing a framed and matted work of art off a gallery showroom floor, to ask to have the piece opened up for inspection. It's also appropriate to take your business to a different establishment.

The Value Based on Condition

Obviously a mint condition print is the most highly prized, but what about a non-mint condition print? What is its value? There are no right answers to this question, because the value is ultimately determined by the marketplace; however, by using a scale of 1 to 10, one can estimate potential values.

10 – Full Value - A perfect mint condition print.

8 – 80% of the Full Value - Any print with a perfect image but an imperfect border, such as a border bend, tape marks or any other discoloration that would be hidden by framing.

6 – 60% of the Full Value - Any print with a problem in the image, generally undetectable unless expertly examined.

4 – 40% of the Full Value - Any print with an imperfection that intrudes onto the edge of the image, but can be covered by matting even though it would mean covering part of the image.

2 – 20% of the Full Value - Any print that has a serious imperfection in the image, such as fading, a hole, or something so significant that it cannot be missed when viewed.

There is no science to determining the value of a non-mint print. The value is determined by what a buyer is willing to pay. Still, these numbers should offer some guidance and insight.

Replacing a Non-Mint Condition Print

Okay. Imagine this scenario: Your 4-year-old child, the next Michael Jordan, dribbles the ball down the hall, around the lamp, over the coffee table, into the dining room — his highchair guards him close, but he fakes right, he looks left, he arches and shoots… and he scores a hole right through your favorite print. What do you do?

First of all, put the kid up for adoption. Then call your preferred art gallery and see if there might be a way to get the print replaced. In most cases, the publisher will have overprinted the edition by about 10 percent to allow for damage that might occur during shipping and to compensate for flaws and imperfections. One of these extra prints — sometimes referred to as "blanks" because they're not yet numbered — may be available to you at either no charge or for a nominal fee. Keep in mind that the older the print, the less likely the chance it will still be available.

Should a replacement print still be available, the publisher will request that the original print be packed up and returned to them. After they receive it, they'll destroy it and renumber one of the blanks with the destroyed print's number.

Some publishers only offer replacements for a limited time, while others offer them indefinitely. Expect the cost of getting the print replaced to fall somewhere between $15 and $50 plus all shipping charges. It's a small price to pay in comparison to having to buy a completely new print.

11
Storage and Shipping

Packing for Storage

Your intention was to frame the print right away, but economics determined that you should save a few pennies first. Or, perhaps your plan was to buy the print, keep it as an investment, and then sell it when you could clear a cool million buckaroos. Either way, paper art prints need to be carefully packed if they're not going straight into a mat and frame.

Most art prints today come in protective acid-free folders or envelopes. Inside the folder will be a one-ply, acid-free buffer paper and often times a board to offer the print support. This is adequate protection if the print is being kept in a file drawer or a plastic portfolio sleeve. But, what if you don't have a drawer or a sleeve? Then how should you protect the print?

The first thing to do is make sure that nothing is touching the print that could lead to discoloration from acid-burn. Ideally, all biographical cards and authentication paperwork will be taken out of the envelope, too, since there's no guarantee that they are harm-free. Then the envelope with the print inside should be sandwiched between two sheets of an acid-free board. After you've done this just lay the boards flat in a safe area within a room that is humidity controlled. If you want, you can put a couple small pieces of tape on the boards to hold them together.

Also, avoid using any corrugated material. Corrugated cardboard is very high in acid content and it can be very harmful to any piece of art. If your print arrives in a corrugated box or packing and you don't plan to frame the print within a couple of months, you should remove the print and dispose of the corrugated packing material.

The Harm of the Roll

While rolling a print and putting it in a tube may seem like a space saving way to store a print and an economical way to ship one, it can cause irreparable damage to a work of art and it should be avoided whenever possible.

If an art print has to be rolled, there is a method to use that can reduce the amount of damage. Nearly all paper has a grain to it and if the print is rolled with the grain less damage will be done. To find the grain, curl the paper slightly horizontally and then do the same vertically. Hopefully,

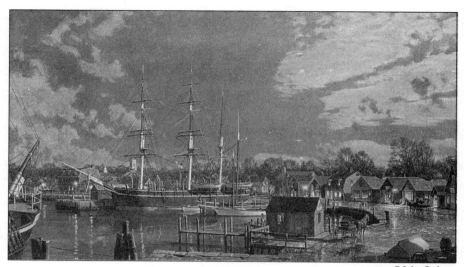

John Stobart's art is carefully researched to offer an element of history. (Pictured is Stobart's "Mystic Seaport")

you'll be able to feel some resistance one of the ways. The least resistant direction is the way the grain runs and this is the direction that the print should be rolled.

The rolling should then be done as loosely as possible. For instance, it's much better to use a tube with a 6-inch diameter than one with a 3-inch diameter. And, if the print is being rolled for storage, you can roll it around the outside of the tube instead of rolling it tighter and putting it on the inside.

Whether you end up rolling your print around the outside of a tube or inserting it within, it's always important to roll the print around a piece of acid-free barrier paper so no part of the print comes in actual contact with the tube. Most tubes are made of Kraft paper and are very high in acid content. Consequently, they can discolor items that come in contact with them. The barrier paper can provide the artwork with significant protection in this situation.

At the first opportunity, take the picture out of the rolled format and either store it flat or arrange to have it framed. Rolling for a long period of time causes the paper fibers to stretch abnormally and if it stays that way for a long period of time, the roll can become permanent.

The Art of Shipping Unframed Prints

Have you ever looked out your window seat on a plane just above the area where the baggage handlers put the suitcases on the conveyer belt and seen someone's luggage go flying over the conveyer belt and land on the

There is an art to packing an unframed work of art for shipping. (Photo by Alan Brown)

tarmac? Well, that's the kind of care you can expect when you ship your precious artwork from Point A to Point B.

Perhaps you're one of a rare breed that enjoys filing insurance claims and fighting with shippers over who was really at fault. But if you're not a glutton for punishment and abuse, then you need to take extreme care to pack your artwork well before shipping.

If there's a gallery near you, stop in and see if they have a print box you can use. Most galleries have extra boxes and they'll probably just give you one as a courtesy. But, if there isn't a gallery nearby, then you'll have to make your own shipping container.

If you'll be making your own box, the first thing you'll need is four sheets of heavy corrugated cardboard cut to at least 4 inches bigger than the print's envelope. You need the boards to be bigger than the envelope to protect the print in case the box is dropped on a corner and crushed. If the print is sitting away from the corner, the risk of damage is reduced significantly.

To attach the print to the cardboard, you'll need to prepare four corner pockets. The easiest way to do this is to take four sheets of 8-1/2 x 11 paper and fold them into quarters (once vertically and once horizontally). Now, center the print on the board and slip it into one of the corner pockets and tape the corner onto the cardboard. Make sure you use a reasonably strong tape at least 2 inches wide — preferably a filament tape, strapping tape or duct tape. Then repeat this procedure until all four corners are securely attached.

Now place one of the sheets of pre-cut cardboard below the first board, and put two sheets above it. Then, tape all four of these boards together. Now, run the tape around all of the edges of the cardboard until all the seams are secure and covered. Next with a red magic marker write "FRAGILE" all over the box and add your address label. You're ready to call the shipper.

Most art prints are shipped via UPS, FedEx, Airborne Express, or RPS, however, if you live in a remote area the U.S. Postal Service can be used as well. Call around for the best price and arrange to have the package picked up or dropped off. And above all, don't forget to add the insurance.

If the picture you are shipping is extremely valuable, it's a good idea to add a sheet of either 1/8-inch tempered hardboard or plywood to each side of the box and tape them down as well. This will give the box more stability and hopefully keep the box from being punctured or crushed.

If the piece is irreplaceable, you should contact your local insurance person before handing the package over to the shipper. Many shippers will not insure irreplaceable items and no matter how well you pack the print, damage can occur and packages can get lost. It's always better to be overly cautious than "boxed" into a corner.

The Art of Shipping Framed Prints

If you need to ship a framed print with glass, you should first consider all the other options. Is there a way to have the picture hand delivered either by you, a friend or a family member? Is the picture small enough to be carried onto a plane and stored in the overhead bin or put into one of the closets on board? Or maybe the person you are shipping it to is coming to visit, and you can just give it to them in person and make it their problem to get it home. Now, that's a plan—just pass the buck to someone else.

The problem with framed art is the glass can break and if it does, most of the time it will damage the art. All you can do is take the best caution possible and pray that the picture will get to its destination safely. You might be able to convince your local gallery to do the shipping for you. If they'll do it, ask them how much experience they have shipping glassed art and if they are experienced, you might be wise to let them do it.

If you decide to handle the packing and shipping on your own, you'll need to build a wooden crate. To determine the size of the crate, lay the picture on the ground. Measure the length and width and add about 6 inches to each. This will allow for 3 inches of padding on the sides. Next, measure the height of the frame and add about 4 inches. This will be the size of your box. For example if the picture is 16 x 20 x 2, you'd need a box 22 x 26 x 6.

The easiest way to make the box is with 1 x 6 or 1 x 8 pine and a couple of sheets of inexpensive plywood. Simply lay the 1 x 6's on their edges and nail them together to form a rectangular box. Then screw a sheet of plywood to the box for a base.

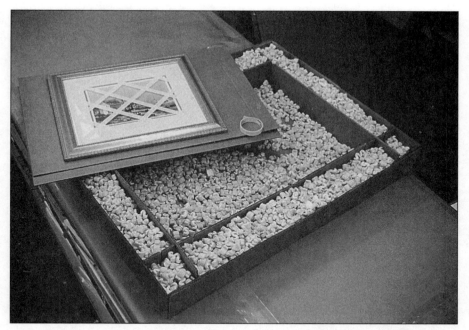

When framed art is properly prepared for shipping, the art usually arrives in pristine condition. (Photo by Alan Brown)

Next, you'll need to reinforce the glass. By doing this, if the glass does break then hopefully the tape will hold it together and protect the picture. The best and easiest way to do this is with electrical tape or masking tape. Just make a checkerboard design with the tape on the glass, allowing approximately 1 inch of space between each strip.

Next, get some foam, bubble wrap or plastic foam popcorn and float the picture in the box until it's well-cushioned and evenly protected on all sides. Make sure it's snug, so it won't slide around during shipping. When you're done, just screw the other piece of plywood to the box, find your handy red marking pen and write "FRAGILE" all over every side. Now you're ready to select a carrier.

The best way to ship a framed and glassed work of art is by air — FedEx, UPS overnight or second-day air or Burlington Air Freight. Air shipments aren't moved as often and the risk of damage is reduced. Make sure you take the insurance option and then just keep your fingers crossed that you get a phone call from the person to whom the shipment went and they sound happy and excited instead of broken hearted.

Robert Bateman (Photo courtesy of Mill Pond Press)

12

Framing

Choosing the Right Framer

Definitely don't pick a framer because you are attracted to their ad in the yellow pages or because their neon sign looks pretty. And don't choose a framer because their prices are lower than the competition.

In most areas, all the framers buy from the same suppliers. They'll buy their glass from distributor A, and their mat board from distributor B. They'll buy their wood moulding from distributor C, and they'll buy their hardware from distributor D. If they are selling the same materials to you and offering the same services, there should be very little price variation. If someone is offering framing that is significantly cheaper than their competition, then you can be assured that they are not framing with the same high-quality materials. If you really care whether your piece of art lasts a lifetime then you should be framing it somewhere better.

Visit a number of frame shops and take time to walk around their stores and study the works of art they have on display and for sale. Every framer should have at least a limited amount of framed art on display. How is the technical quality of their mat cutting? The corners of each mat should be cut to precise 90-degree angles and the beveled edges of the mats should be sharp, not rough or rounded. And, there should be no evidence of over-cut corners. Their frames should meet squarely and shouldn't feel flexible or loose. Nail holes should be hidden and practically non-existent to the naked eye. And, they should offer conservation-quality glass as well as regular glass products.

Take a look around their showroom for cleanliness and organization. Two framed works of art should never be touching without a pad of some type in between to keep the wire of one from scratching the finish of another. And, their unframed works of art should be crisp, clean and protected with portfolio sleeves or shrink-wrap. If they show unframed works that are bent in the corners, or dirty on the borders, then it would be a wise assumption that their idea of what constitutes a mint-condition print is lacking.

Note if they have experience framing works of art valued higher than yours. And, if they have expertise framing works by your artist of choice it's an excellent sign. Ask if they are members of the PPFA (Professional Picture

© Jim Daly

Jim Daly's paintings of nostalgia and Americana have garnered him dozens of awards and a large base of collectors. (Pictured is Daly's "Home Team – Zero")

Framers Association) and if they have a CPF (Certified Picture Framer) on staff. This will let you know that they are trying to remain educated and on the cutting edge of developments in the framing industry.

As for their ability to design a well-proportioned, aesthetically pleasing framed work of art, that's a personal decision. It's an important decision, but it doesn't compare to the importance of making sure a work of art, with the potential to increase in price, is properly framed with the best conservation materials available. Many framers can execute an attractive framing job, but not everyone has the knowledge and experience to make it last a lifetime.

The PPFA

The Professional Picture Framers Association is the organization based in Richmond, Va., that is accepted nationally as the framing industry's largest framing association. Membership does not guarantee professionalism nor does it guarantee quality, but framers who at least care enough to become a member are generally doing so to remain aware of the most current processes, materials and manufacturers in an effort to keep themselves on the cutting edge of the framing business. Members of the PPFA can normally be recognized by a decal that they proudly display on their door or window.

The fact that your framer is a member is no guarantee that the framer isn't leading clients awry. But, without a doubt, the collector's chances of receiving the industry's best care are with framers that are members of this organization. If you need to check to see if a framer is a member, or if you have a question about what constitutes proper framing contact the PPFA at 1-800-832-PPFA.

What is a CPF?

The PPFA now offers the designation Certified Picture Framer (CPF) to people in the business of framing, who can pass an in-depth test about the materials and the processes that are used to frame works of art. If you choose a CPF to do your framing, your chances of having your work preserved and handled properly are increased. The framer has taken another step to earn your confidence by furthering their own knowledge.

But again, you can never be too careful when it's your precious work of art that is at risk.

Museum Mounting

The question should be phrased, "What is proper museum mounting?"

The first thing all collectors must accept is that no matter how reputable, no matter how successful, no matter how experienced and no matter how big the words your framer uses, he may be ruining your pictures by improperly mounting and matting your artwork. Forget the terminology and the neon lights, make yourself knowledgeable and ask your framer lots of questions to adequately protect yourself.

Now, let's dispel the notion that museum mounting means your picture has been safely mounted. That's the same as saying that because your shoes are made of leather, they won't fall apart. There are different quality leather shoes and there are different levels of museum mounting. Some levels are for a lifetime, while others aren't worth a walk around the block.

To properly museum mount a work of art, the framer must use at least 4-ply (about 1/8-inch) museum-quality, 100-percent rag board against the front of the picture and the back of the picture. Then the picture must be attached to the backing board with archival/museum quality flanges or corner pockets. Any additional matting must either be museum-quality 100-percent rag or conservation-quality 100-percent rag core boards.

The problem is many framers cut corners. Instead of using 4-ply boards, they'll use either 1-ply or 2-ply boards. Instead of using museum-quality, all rag matting, they use the all rag core boards against the picture. And, since nobody can see it anyway, they skip the high quality board behind the picture. But, the biggest problem is the errant way many framers attach prints. The only approved methods allow for the picture to be simply removed from its corners or flanges without any permanent scarring or discoloration. Any other methods used are not to the industry's standards for museum mounting.

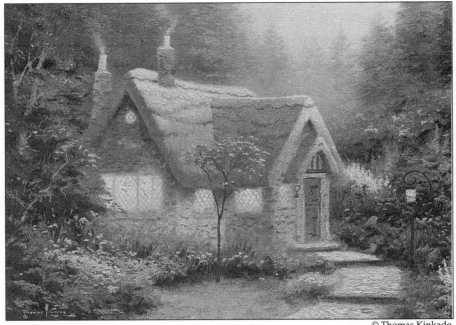

Thomas Kinkade's romantic hideaways have made him one of the nation's leading artists. (Pictured is Kinkade's "Cedar Nook Cottage")

The reason to museum mount a work of art is so it will last forever. If, after 100 years, the print can be removed from its framing and no expert who inspected every inch of the print — front and back — could tell that the print had ever been framed, then the print has undoubtedly been properly museum mounted.

Corner Pockets

One of the most common and professionally acceptable ways to attach a limited edition print underneath the matting is by using corner pockets. The technique is similar to the technique used to hold photographs in place within a photo album. Each corner of the picture is slipped into a triangular pocket made of an acid-free material — paper or Mylar — and the corners are then glued or taped to the backing board. Since the picture is only resting within the corners, this method allows the print to be easily removed without any visible damage or permanent alteration of the paper fibers.

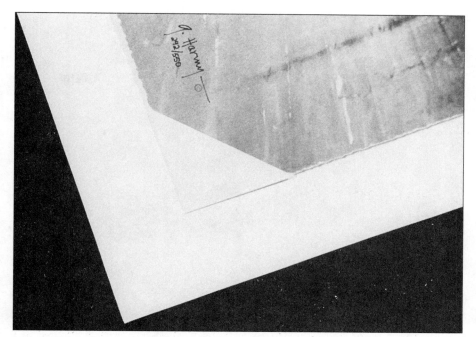

The proper use of corner pockets can secure a print for generations to come. (Photo by Alan Brown)

When corner pocketing a print, it is very important that the framer use an acid-free material. If a non-acid-free material is used, the corner could cause significant harm to the print over time. Furthermore, the glue or tape that adheres the pocket to the backing board must also be free of acid.

Flanges

Flanging is another acceptable way to attach a print to a backing board underneath a mat. A flange is a once-folded piece of paper or Mylar. When flanges are used, they are placed on all four sides of the print and the print is carefully inserted into each flange. The flanges are then glued or taped to the backing board. Larger pieces may require more than one flange per side.

When done properly the work of art is easily removed by lifting the top edge of the flange, and then the print can be removed without any evidence of previous framing.

Rice Paper Hinges

Another method used to attach a print to matting within a frame is to use tabs made of rice paper and wheat starch paste. This method was the most widely accepted way to attach a print for decades by conservators; however, if it's not done with precision it can cause irreparable damage to a

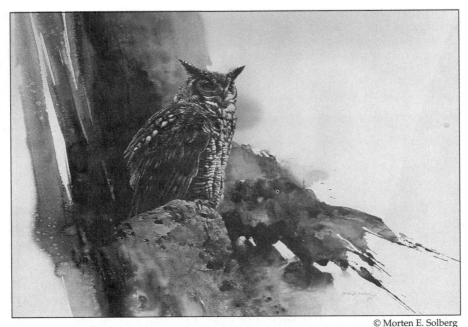

Morten E. Solberg combines contemporary backgrounds with highly detailed wildlife subjects. (Featured is Solberg's "The Grand Duke")

valuable work of art. Because of the risks associated with this technique and with flanges and corner pockets easily accessible to the marketplace, rice paper hinges are no longer the method of choice.

Rice paper tabs are made from hand-torn mulberry paper. The paper is torn into 1-inch squares and pasted to the backing board and the print with a mixture of wheat and starch. The tab should never extend more than 1/4-inch onto the back of the art, and the tab and adhesive should never be pressed to help it adhere. If the process is done properly a light weight can be used to help set the adhesive instead. Because you are using an adhesive, applying pressure to the paste can cause it to soak into the fibers of the print's paper and it can become nearly impossible to remove.

The only benefit of this technique is that if the frame falls, the tabs will tear and the paper will gently slide down without any damage. With other methods, if the frame took a hard fall, the corner pockets or flanges might not release the art and the force might crush or dent the paper.

To remove the tabs from the print, the tabs are first cut in half, then distilled water is carefully applied to the hinge until it lets loose. Then the remnants of the paste can be carefully scraped from the print.

This entire process is risky. Any time you are adding an adhesive to a piece of paper you are taking a huge risk. Though framers may suggest this as a wise way to adhere a print, there are better, safer methods available for prints today.

The Purpose of Matting

Matting of prints serves two purposes. The first is to visually set off the picture for decorative purposes and the other is to preserve the work and protect it from elements that could damage it over time.

There are a couple of ways that matting helps preserve a print. First of all, it keeps the paper from having direct contact with the frame. Wood is highly acidic and if a piece of paper is in contact with a frame for an extended period of time, there is tremendous risk that the paper will begin to yellow from acid-burn.

Secondly, the matting provides a way to keep the glass off of the picture while creating an air space that will reduce the risk of damage from humidity. In cases where a picture experiences changes in humidity, condensation can build within the matting and frame. With matting, the condensation will develop on the glass and not the print. Without the matting, the condensation can develop on the print and permanent damage can be caused to the paper and the ink. Furthermore, when condensation builds between the paper and the glass, if there is no matting there is tremendous risk that the art and glass will bond together.

Conservation issues aside, most collectors know of matting solely for its aesthetic purpose. By using a proper combination of mat colors and proportions, a piece of art can blend smoothly into its surroundings, while being dramatized for individual beauty.

Selecting the Matting Colors

The walls in your living room are a bright white. The carpet is blue and you have a brand new beautiful eagle print that you want to frame and hang over your blue sofa. You have a great idea. If you use a nice red mat on the print, the room will take on a very patriotic, sort of red, white and blue motif. So you go to your local framer and tell him your idea. If he agrees with you, it might be time to find a new framer. Hopefully, he doesn't live 100 percent by the concept that the customer is always right, and he'll suggest instead that you buy a flag and a copy of the National Anthem.

If the framer is a professional, he'll suggest that you put the room colors aside for a moment and take a look at the color of the art. Always remember, if you are committed to putting a piece of art in a room, then you are also making a commitment to the colors found in the picture. The best thing you can do is figure out how to frame the picture to make it look its best, and then after you are totally finished, consider how it might look in the room. Then place your order. Never make the mistake of doing it in reverse.

If you were going to use a double mat, normally you'd want to select a neutral top mat and an accent color to be featured underneath. Both of the colors should be found in the picture and should be somewhat dominant. Do not make the matting so different or so bold that your eye will notice it before the art.

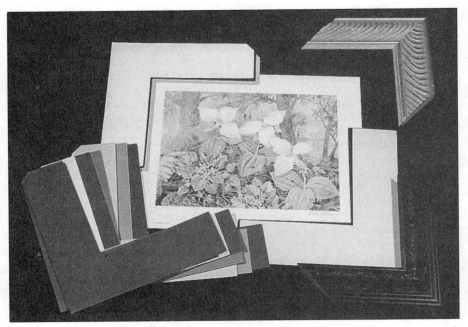

Selecting the proper mat and frame combination can help a picture to blend perfectly into its surroundings. (Photo by Alan Brown)

The best compliment you can receive when you take your picture home is when someone looks at the picture and they say, "Wow, what a great piece of art." If they say, "Wow, what great framing," instead, then you know your color choices probably weren't the best.

The Importance of Acid-Free Mats

If there's one area of framing not to skimp on, it is the necessity to use conservation-quality mat boards. With the matting making direct contact on both sides of a picture, proper matting can greatly increase the lifetime of a piece of art. Conversely, improper matting can single-handedly destroy the art within just a few years.

There are basically three types of matting available for framing: rag boards, pH neutral wood pulp boards and untreated wood pulp boards. The preference is for rag boards. Wood pulp boards are made from trees. Trees are composed of a chemical called lignin, which holds the cells of the tree together. After the tree dies, the lignin naturally releases a gaseous acid when it comes in contact with light. This acid can turn a print orange within a short period of time — often just a few years. If you've ever seen a newspaper that sat outside in the sun, you may have noticed that it started turning orange. That orange discoloration is known as acid-burn and the

Nita Engle is regarded as perhaps the leading watercolorist of our generation, and her offset lithographic prints replicate her ability to perfection. (Featured is Engle's "Light in the Willows")

goal with an art print is to keep that from happening to it and destroying the value of the work.

To protect artwork, mat board manufacturers traditionally add a buffering agent to the wood pulp, which neutralizes the acid content and makes it pH neutral. With this treatment, the boards generally protect the art for anywhere from five to fifteen years depending on various intangibles not limited to light, temperature and humidity.

The better option is to use an all rag board. All rag boards are made of cotton which is nearly 100 percent lignin-free and naturally pH neutral. Tests indicate that most all rag mat boards have less than .17 percent of lignin in them. This minimal amount of lignin is not considered a threat to most art pieces. However, mat board manufacturers often still add a buffering agent to the all rag board to give it a bit of extra protection and additional resistance from outside factors like pollution and other elements that might come in contact with the art.

The Library of Congress recommends using all rag boards on any piece of art with investment potential or sentimental meaning. If you care enough about your art to want to frame it and display it, spend the extra money for an all rag mat board that will protect it and increase its life tremendously.

Artist G. Harvey has established himself as one of the art industry's leaders in three genres—military art, Western art and cityscapes. (Shown is Harvey's "A Breakfast Out")

A Guide to Standard Measurements

The matting dimensions chosen can make or break the perfect framing job. It can accentuate the print or it can create a distraction that will impede your enjoyment of the work. The key is to select the perfect balance of frame width and mat width. For most situations, the following chart will be an advantageous guide:

Image Size	Top/Sides	Bottom/Horizontal	Bottom/Vertical
5 X 7	2 1/4	2 3/8	2 1/2
8 X 10	2 1/2	2 5/8	2 3/4
11 X 14	2 3/4	3	3 1/8
16 X 20	3	3 1/4	3 1/2
20 X 24	3 1/4	3 5/8	3 3/4
24 X 30	3 1/2	3 7/8	4
24 X 36	3 3/4	4 1/8	4 1/2
Larger	4	4 1/2	4 3/4

The chart assumes that the picture is a rectangle or square and the frame that accompanies the matting is of average width. Should the width of the frame be smaller than the average, reduce the matting dimensions one notch. If the width of the frame is significantly larger than average, increase one notch.

Also, note how the bottom of the mat is always slightly wider than the sides and top. This is a design element that keeps the picture from appearing top heavy. In most cases, the eye won't be able to detect the extra bottom weight, but without it, there is the illusion that the bottom is actually smaller than the sides and top.

Some collectors are convinced that mat width is simply a matter of personal taste, but it's not. Proper framing sets off the image, keeping the focus away from the framing. When it's done correctly, no one says a word. When it's done incorrectly most people can't put their finger on the problem, they just know that they don't like the result.

Glazing for Protection

Aside from the obvious drawbacks — possible breakage and glare — glass serves an irreplaceable preservative role for paper art prints. Without it, the lifetime of a paper art print would be practically non-existent. Dust and dirt particles could never be lifted without permanent damage. And, if the print happens to be touched by someone's hand, the oils from the skin could leave a mark that would be next to impossible to remove. With glass, all it takes is a soft cloth and a bottle of window cleaner and the print looks again like new.

The most common complaint about glass is the glare, and today there are a number of ways to reduce or eliminate it. The obvious way is to switch to a low-glare or non-glare product. But, another option is to investigate whether the print might come on canvas, since canvas prints do not need glass.

Selecting the Right Type of Glass

Glass, or glazing as it is commonly called is a necessity for framed paper prints. The goal of the glass is to provide your print with protection from any dirt and soil that could irreparably damage it. However, from the moment you frame your print and that important piece of glass is added, you increase the risk of fading as a result of exposure to light and harmful ultraviolet rays.

There are six basic types of glass: clear regular-glare glass, clear low-glare glass and frosted no-glare glass. And, the same three types are also available with added ultraviolet protection: conservation clear regular-glare glass, conservation clear low-glare glass and conservation frosted no-glare glass.

Clear regular-glare glass is like window glass. It is the standard glass that you'll probably get unless you ask about alternatives. Clear low-glare glass is a completely clear, coated glass that reduces the glare to about 5 percent. Frosted no-glare glass is not a completely clear product. In order to reduce glare, a frosted coating is added to either one or both sides of the glass depending on the manufacturer.

Each type of glass is also available with a conservation coating that will help prevent the work from fading. The conservation coating will help block up to 97 percent of the most damaging ultraviolet rays, depending on the manufacturer.

It is important to always remember that any print that is exposed to light is at risk for fading. The best coatings can only reduce the risk and slow down the damage. Regardless of the type of glass you choose, keep your pictures out of direct sunlight and away from fluorescent lights.

The cost of the various types of glass will vary depending on the framer and the glass manufacturer. However, as a rule, frosted no-glare glass is generally twice the price of regular glass. Clear low-glare glass is six times the price of regular glass. And, conservation coatings double the price of each type of glass.

The best rule of thumb is to never use frosted glass. The purpose of reducing glare is so you can enjoy your fine work of art without the distortion of glare. However, with a frosted product, even when the glare isn't normally bothersome, your picture will appear blurry. So, you'll never be able to see your work clearly. Otherwise, use the best type of glass you can afford.

Other products do exist. For instance, plexi-glass comes either clear or low-glare and with or without conservation coatings. Since plexi-glass is a plastic material, it can scratch so it is best used only for items that need to be shipped.

Selecting the Frame

Frame selection is more a matter of taste than a necessity for conservation. Some people prefer to frame their works of art in wooden frames, others metal. Some prefer a painted finish, others a wood grain. And, some prefer thin frames, while others like theirs wide.

Michael Deas' print "Interlude" is set off dramatically with a neutral frame and matting combination.

Aesthetically, it's best for the matting to be at least 1-1/2 times the width of the frame, so usually very wide frames are reserved for items that don't need matting at all — canvas prints and original paintings. But don't make the mistake of getting a frame that's too small, either, because aesthetics aside, there could be a problem with the ability of the frame to hold the weight of the matting, glass and backing boards without splitting in the corners or bowing out in the center.

For rooms that have a consistent wood throughout (oak, cherry or walnut for instance), the best idea is to choose a frame of the same wood type with a similar stain color as long as it brings out similar colors in the

picture. If the color of the stain doesn't complement the color of the picture, then the best solution is to avoid competition and use a gold, silver or painted (not stained) frame.

The ideal situation is to select a frame that highlights the picture. If the picture has a lot of red, take a look at the cherry frame selection. If the picture has a lot of blue, then take a look at the frames with blue paint or stain. If the perfect frame to make the picture look its best won't look good in the room, then make an alternate selection.

The best framing is done when the art is treated like a window to another world — a world of nature, fantasy or abstraction. Also, the framing should be selected primarily for the benefit of the picture and secondarily for the room.

Why is Framing SO Expensive?

Whether you're the type of person that prefers to drive a Mercedes, or tool around in a Chevrolet, if you have purchased a good piece of art, then you should want it to last and hold its value. The only way to do this is by spending the money for quality framing materials including acid-free matting, conservation glass and quality frames. The price you'll pay is less a reflection of frame shop overhead and expertise and more a reflection on the materials used. Good framing costs money, but it's well worth the price.

A framing job is made up of a number of materials. The value of some can be differentiated by the naked eye, while the value of others may not be evident until irreversible damage has been done. Nationally, the average sofa size print will cost between $200 to $300 to frame adequately. With reasonable care, a print protected this way can last forever.

There will be discounted ways to frame the same print for as little as $110 using non-conservation quality standards, but by doing so, the time the work remains in mint condition might be reduced to 10 years or fewer.

To exemplify how a sofa-size print might cost more than $200 to frame properly, consider each of the materials and their cost to the consumer.

Conservation glass - $100
12 feet of solid wood moulding - $120
A pre-cut acid-free double mat - $30
Museum mounting - $15
Fit, backing and assembly - $10
Total cost - $275.00

Then consider how the job might cost only $110:

Regular glass - $15
12 feet of discount moulding - $70
A pre-cut non-acid-free mat - $15
Fit, backing and assembly - $10
Total cost - $110

Saving $165 might sound quite tempting, but consider the aesthetic and financial value of the print in ten years. Using the best conservation materials, the print should look like new and it should be in mint condition while retaining its full value. The discount-framed print will likely be yellowing from acid-burn, its inks will likely be fading, and, you'll probably want to replace it because aesthetically it's going to look old, dirty and worn. The value of the print will be tremendously less than the mint condition one. In fact, it's very likely that its condition will be so weak that reselling it will be nearly impossible. It's also likely that you'll be spending more than the $165 previously saved to replace the picture with another work of art that's crisper, cleaner and newer.

On the other hand the print framed with conservation framing will be ready for another ten or twenty years of enjoyment and should an opportunity to sell it arise, the marketplace will welcome it with open arms. The extra money spent for conservation protection will be money well spent.

Don't Forget the Backing

Remember it's not what people look like on the outside that counts, it's what makes them up on the inside. Beauty is more than skin deep with framing as well. Don't underestimate the use of an acid-free or all rag board behind the picture and a piece of 1/8" or wider foam board behind that board to help reduce potential damage by changes in humidity. And, always attach a piece of paper over the back of the frame to make it harder for dust and insects to get to your art.

Make Sure it's Archival

The term archival refers to materials that are of museum quality standards. They have no acid content and are made of nothing that has properties known to change over time. When framing a precious work of art, archival materials should be used wherever possible.

The Permanence of Dry Mounting

Dry mounting is a heat and pressure system used to attach paper art to a backing board. Items that are dry mounted shouldn't ever ripple unless the mounting releases, as it does in rare cases where it wasn't done properly.

The way the process works is with a waxy adhesive tissue and a heat, or heat and vacuum press. Using temperatures of over 180 degrees, the adhesive melts and bonds the picture permanently to the board. Since the process is practically irreversible, any art prints attached this way are considered no longer in mint condition and they're tremendously devalued.

The only prints that should be dry mounted are posters and open-edition prints that have little if any investment potential. Generally, these types of prints are produced on thinner, lower-grade paper, so the dry mounting is a necessary step to keep them looking flat and pleasing to the

James C. Christensen's sense of humor is almost always as evident as it is in his painting called "Sometimes the Spirit Touches us Through our Weaknesses"

eye. Limited edition art prints must be attached using non-permanent and non-paper altering attachment methods. So, if you have a print of value, or with potential to be of value, it should never be adhered using this or any other similar procedure.

13

Investing in Art

The World's Best Investment: Fine Art

Never invest more in a piece of art than you can afford, and never buy anything you don't like. If you follow that simple rule, you'll never make an art-buying decision you regret — and you'll always get tremendous value from your art purchases. However, if you are looking for a little more — perhaps a little financial gain — then you'll need more than knowledge and experience. You'll also need a little luck.

Buying for Investment

There's no science to buying a piece of art for investment. Some prints that look like sure bets will falter on the resale market, while others will emerge from nowhere and become the season's hottest rage. But, by watching for the three main keys — originality, collector sincerity and promotion — collectors can at least make an educated and wise art-investment decision.

The first thing to look for is uniqueness and originality. There are plenty of talented technicians capable of illustrating a thought on paper and bringing it to life with a brush. But what separates the good artists from the great artists isn't technical prowess as much as an innate ability to come up with creative ideas that are new and innovative. Quite often it seems like everything in art has been done before, but it hasn't. Occasionally, someone still comes along with a clever theme and a fresh approach and those are the artists that collectors should be watching. Those are the artists that can change the art world and can make investing in art very lucrative. The artists that care enough to be original are the ones who art investors should care enough about to collect.

Secondly, collectors need to see that the public is responding to the art with sincerity. Artists don't come out of the blocks, immediately sell out their first edition, and become a great investment overnight. It is a process. Most of the time when a new artist seems to take the art world by storm, it's just a product of hype. In a few years, when the hype subsides and the collectors come back to earth, they'll find that the artist was just a "flash in the pan" and not an investment-worthy commodity. What collectors should be looking for are artists who people really seem to like and enjoy, rather than those who they feel will bring them financial rewards. Art should

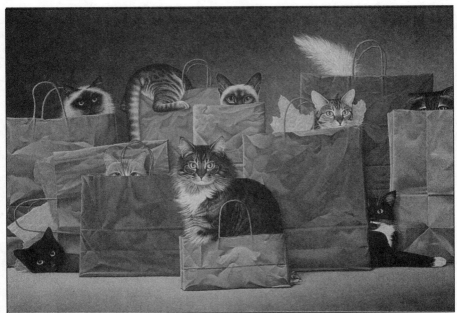

Braldt Bralds' art often tells a humorous story as in this print "Bag Ladies."

move people and excite them. When people purchase art because it provokes an emotional response in them, it ends up on the wall and becomes part of their family, rather than tossed under the bed and forgotten about. And the harder it is to get people to part with their art purchases, the more valuable it becomes.

And the final key is promotion and market growth. There are many great artists who will never make it big because markets for their work have stopped growing. An artist may be one of a region's greatest treasures, but if his or her individual market doesn't continue to increase in size, eventually the artist may find that collectors of his or her work have filled their walls and interest has waned due to oversaturation.

Investing in art takes an eye for talent and a lot of luck. Sometimes the best rule of thumb seems to be if you like it so much that you can't live without it, then others probably feel the same way, too. However, if you base every purchase on that philosophy, you probably won't end up selling as often as you buy, and that's all right. That means you didn't end up becoming an art investor — you became an art collector.

Selling for Investment

Sometimes it's easy to know when to sell a work of art. Perhaps it no longer fits into your decorating plans or you've simply grown tired of looking at it. Maybe, you're considering making a change because a new artist or a new picture has come along and you need to clear some wall

space. Or perhaps you want to sell the work of art to afford a new car, take a needed vacation or help pay for your child's college education. In any of these cases, the decision to sell is often easy and whether or not the print has the potential to increase in value over the next few years is secondary to the necessity of cashing in your investment now.

Other times, a print was purchased strictly as an investment and the price has done nothing but climb steadily since then. Your friends and neighbors have since marveled over your brilliance and acute knowledge of art collecting, so you think the reasons to hold on to that piece of art are abundant and obvious. But you may be making a critical mistake. There are two sides to investing in art — knowing what to buy and knowing when to sell it. Many collectors exhibit astute judgment with the former, but have no idea how to master the latter.

There are a few tips to help you know when the time might be right to sell a work of art. First of all, keep an eye on the market. Just as the stock market fluctuates, the print market can do the same. The most common trends are for prices to be lowest during the summer months when people are more concerned with exterior decorating than interior decorating. Then, around the Christmas holiday season, values will be highest due to gift giving.

Secondly, keep an eye on the artist's popularity. You want to see new releases coming out and selling out. If they used to sell out routinely in the past and they rarely do anymore, then there's a good chance that collectors will start losing confidence in the artist. Perhaps the edition sizes are now bigger or the artist is no longer in favor. Regardless of the reason, when collectors no longer see an artist as a strong investment, they often shift their attention to another.

There are also always going to be generational trends in art collecting. The average age of a print collector is about 30 to 45 years old. This age corresponds to the age when most people have settled into their first home and have a few extra dollars to decorate and/or invest. And, very few people end up decorating the same way their parents did. So as one generation begins to wind down their art buying another generation begins theirs. With this in mind, it's very rare for an artist to remain on top for more than 15 years. If an artist has been popular for more than a decade, then it might be wise to keep an eye out for the tide to turn.

In reality, if you hold onto a work of art too long, it can become difficult to sell and if it is resold, often it's for much less than the peak value. If you are considering selling a work of art, sit down with your preferred gallery and explain to them your concerns. Ask for advice and then make an educated decision.

There's no clear-cut answer to knowing when to sell a work of art. However, it's always better and easier to sell too soon than too late. If you sell too soon, at least you'll reap a benefit. If you sell too late, you may find it difficult to reap any benefit at all. If you are serious about investing in art, remember to be a wise collector. Keep a pulse on the market not just for buying but for selling as well.

Framed or Unframed for Greatest Value

At first it seems a natural assumption that a framed print would be more valuable than an unframed one. The framed print includes the dollars expended on the framing in addition to the price of the print. So doesn't that mean it's worth more? Not necessarily! Too often, not only does the framing method improperly preserve a print, but it damages the print permanently as well.

But what if the print has been properly framed? Then what about the value? If the print has been properly framed and if the print hasn't been exposed to elements that have caused it to fade or mildew, then in most cases the value of the print will be comparable to the highest price the marketplace offers for the image. The framing will not have a negative impact on the value.

The most common problems with framed prints are the way they're attached to the backing board or the matting, and the damage caused by low-grade mat boards. The only acceptable methods do not alter the art in any way. The ultimate test is to remove the print from the framing and allow an expert to look it over. If the expert cannot tell that the print had ever been framed after studying the front and the back of the print, then the framing has probably been done properly.

If a print is properly framed, in theory it's better protected than an unframed print. Consider the things that damage an unframed print — dirt, bends, dings, mildew, rippling, insects and more. A correctly framed print is void of most of those risks.

Properly framing a piece of art is like placing it in a protective viewing box. It can be enjoyed as decoration and still be an investment. So don't resist framing your work of art. Just make sure it's framed correctly.

Recovering the Cost of Framing

Your favorite colors are lime green and turquoise, so you've chosen to frame all of your works of art with double mats using both of those colors. Of course, because you're a creative designer, sometimes you use the lime mat on top and other times you use the turquoise. No one will ever say that you don't enjoy variety. So how might this affect the value should you decide to sell one of your prized art possessions?

Many collectors that frame their art for display prefer to select their own mat and frame colors, or to use the advice of a frame shop or art gallery with which they've grown comfortable. For this reason, many collectors prefer to purchase their art unframed or reframe it if it's been previously framed. A collector that decides to sell a work of art that has been framed should think of the framing as the price paid to enjoy the work.

If you'll likely sell your print through a gallery, your best chance to get either a full or partial recovery of your framing dollars is to buy the print and the framing from the same store that you plan to sell the work through. Also, make an effort to listen to the store's framing advice. Colors should be neutral and match the colors in the print as closely as possible. Furthermore, the frame chosen should be reasonably priced.

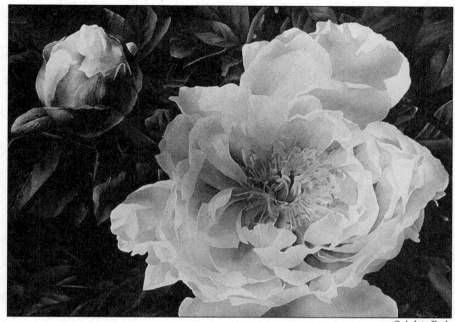

Arleta Pech's florals are perfect for a traditional or a contemporary setting. (Featured is Pech's "Lady of the Evening")

Most galleries have a distinctive style of framing. They generally stick with similar mat colors, proportions and frames, and the collectors who purchase from that gallery tend to develop similar tastes. A work that is not framed in the same format will often be considered an outcast, and this will hamper its sales potential.

If you choose your framing conservatively and cautiously, you should be able to recover at least a portion of your framing dollars. If it doesn't work out that way, it's not the end of the world. The money you spent on the framing was a small price to pay for the enjoyment the print brought you while it was part of your home or office décor.

The Suggestion of Investment: An Art Gallery Taboo

If you've ever bet on a horse race or played the stock market, then you know there are no sure things. Investing in art is a form of gambling, and though there are many times the payoffs might be extraordinary, there will also be many times that the payoffs are not.

In the art industry, it is "taboo" for a dealer to recommend that a picture will be a good investment. There are two sides to an investment — buying and SELLING. If a dealer recommends a print as a good investment, to whom is he guaranteeing you will sell it to? Ask him if he's prepared to buy it, and if he says yes, ask him when.

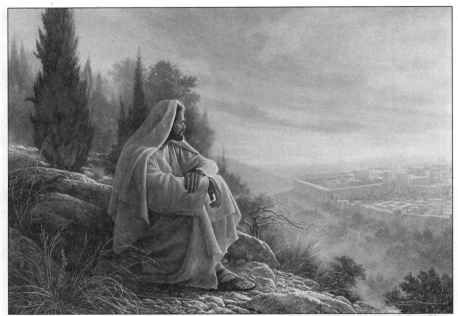

Offset lithographic religious art prints have come to the forefront of collectibility thanks to artists like Greg Olsen. (Pictured is Olsen's "O Jerusalem")

If a piece is that good of an investment that the dealer is prepared to buy it back, it is doubtful that the dealer will want you to buy it. He'll want it all for himself.

When you hear the word "investment" from a gallery owner, the recommendation is to go somewhere else and find a dealer who will be honest with you and who will look out for your best interests.

Invest in the Leader of a Movement

It's funny that an artist, Andy Warhol, is credited with saying that each of us will be famous for 15 minutes. Perhaps his insight was brought forth by his own art world experiences. And maybe we can use his insight to guide our art collecting decisions. Artists do come and go in popularity; however, those who change the art world by altering the way we think about art or by exposing us to new ideas generally have more than the standard 15 minutes of fame. In fact, many of them have a full hour or more. So, how can a collector distinguish between the 15-minute man and the 60-minute superstar? The difference is their creativity and leadership.

In the world of art, very few original thoughts and concepts material-ize. Most artists have learned from their predecessors or heroes and their vision is clouded with unoriginal ideas. However, occasionally an artist comes along with a fresh approach or a new concept and a leader is born.

History shows that today's leaders can become tomorrow's superstars, while yesterday's followers become all but forgotten. If you are intent on making a long-term art investment, it is recommended that you select the leader of a movement or someone with the potential to lead and not invest in a follower. Throughout the history of art, leaders have withstood the test of time more than anyone else.

For example, in offset lithography, Bev Doolittle, the leader of the camouflage art movement, has been successful for more than 10 years. She has consistently provided the market with a unique blend of creative quality images. The market has responded by making her one of the leading offset artists to invest in. A number of her images that were released for $200 and less are valued at over $5000 today. Robert Bateman, the leader of the wildlife art movement, has outlasted thousands of challengers and still remains a strong artist because of the composition of his paintings and the message and stories his work evokes. Like Doolittle, the market has found him a strong investment.

But what about all the other wildlife or camouflage artists who have patterned themselves after Bateman and Doolittle. They've come and gone, never establishing more than a couple years of strong collectibility. They haven't established even 15 minutes of fame, while the Bateman and Doolittle clocks continue ticking on and on.

If you are truly making a purchase with investment in mind, take leadership into consideration. If you're just trying to select a pretty picture to highlight your home or office, then invest in your personal taste and your decorating instincts. Who knows? If your pretty picture becomes the next big thing, you might become a leader and have your own 15 minutes of fame.

Investing in a Prolific Artist

Some artists have the natural ability to create one masterpiece after another, at a speed that makes others wonder if there's any way the artist found time to eat and sleep. Other artists paint at a snail's pace creating one painting for every summer solstice. But, the speed that the artist paints and the number of print releases in a given time span are generally not indicative of the investment potential of the artist.

Artist Thomas Kinkade is most prolific. In a given year, he'll end up releasing approximately 12 new editions. But the key is the collector response. Most of the editions are selling out and realizing fantastic resale values on the secondary market. So, his prolific approach to art doesn't seem to affect him in the marketplace. In fact, it has seemed to aid him.

Prolific artists have the advantage of regular promotion. If an artist releases a print every month, then there's an element of awareness that reminds collectors the artist exists. This can obviously lead to sales of the new image but, as a reminder, it can also lead to sales of older works as well.

On the other hand, Bev Doolittle collectors are lucky to see more than one print a year leave her easel. Yet, her market is extremely strong, too.

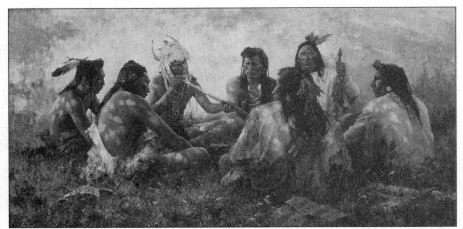

Howard Terpning's impressionistic paintings that depict American Indians have made him one of the nation's most celebrated artists. (Pictured is Terpning's "Crow Pipe Ceremony")

Her once-a-year releases often have collectors lining up to make sure they have the opportunity to take one of her limited editions home.

Every artist is going to paint at a different pace and the response they get from the public is all going to be relative. For each new Doolittle release the editions have to be in the neighborhood of 50,000 prints to offset the huge demand. Kinkade, on the other hand, can release editions of 4,000 prints 12 times a year and he's still 2,000 prints shy of Doolittle's 50,000.

Don't be concerned about how prolific your favorite artist is as long as the marketplace is responding with sellouts and excitement. Realize that all publishers want the artist to be collectible in the marketplace and their edition sizes have been set after extensive research, thought and consideration of long-term collectibility.

Investing in Slow and Steady Prints

One of the more interesting aspects of art collecting relates to the difference between initially strong-selling pieces, which sell out quickly, and slower, steadier sellers, which take more time to sell out. When a print is selling quickly and the marketplace recognizes it, there will be people who will purchase the work as an investment. Their intentions will not be to frame and display the work, but to hold onto the piece until profit opportunities make it advantageous to sell.

With slower, steadier sellers, the people who purchase the work are normally doing so because they enjoy the image and they'll frame it and display it in their home or office. Because the work is mainly for decoration, the people purchasing in this manner are usually not interested in reselling. Therefore, when the print reaches sold-out status, it can be extremely difficult to find and very difficult to obtain. Persuading someone to sell a print bought for love and not investment can oftentimes necessitate a very lucrative offer.

This is the way that the art market was intended to work. However, as the industry has grown, investors and collectors have learned how to recognize the strong sellers, but they may never learn to recognize the slow and steady ones. And the slow and steady sellers might be the best-kept secret in the art world. They are truer to the market's demand, and can turn out to be some of the best art investments of all.

Theme Art: A Different Kind of Investment

If your interest is aviation, sports, or dog art, then there are very high-quality offset lithographic prints for you to collect. Prints like these deserve a spot in the marketplace, but they will never be as universally sought-after as prints of wildlife or landscape subjects, which have a much larger following.

Consider aviation art. There are numerous military buffs and history buffs who find aviation art an exciting forte. But, the marketplace for aviation is primarily male, eliminating most of the women — half of the potential marketplace — by gender alone. Then, among the men interested in print collecting, only a small segment might be interested in pictures of planes, perhaps only 2 percent. So from the start, the marketplace is a small and select group. So how can investing in prints such as these possibly compare to themes such as wildlife art, which have a broader base of potential collectors?

In theory, they can't. But, because the market is smaller to begin with, fewer prints of these subjects are issued. During a year, there may be 1000 different wildlife images made into prints and released into the market-place; however, there may only be 20 aviation prints released. So by de-mand alone, the marketplace keeps the interest in proportion. It's not a phenomenon. It's just an economical reaction to the public's interest.

Furthermore, art that relates to a theme often tugs at the heartstrings of the collectors that have an interest in that theme. The purchasers are often the fanatics — the die-hard followers of a certain sports team, or people whose pets are truly their best friend. These people have a lot of interest in buying these personal remembrances but little or no interest in ever selling them. They buy the art, frame it and hang it — not as much for aesthetic reasons as for personal reasons. And, from the moment they take the picture home, it becomes a priceless family heirloom. The scenario is directly opposite that of broader art themes, like wildlife art, which nor-mally don't evoke the same emotional attachment.

Not surprisingly, with most theme art, the followers are very dedi-cated collectors and they will vie for their favorite images, occasionally forcing sold-out editions and increased secondary market activity. They'll stick with the sports painting even after the team starts losing, and they'll still like the dog even if he gets loose or drags the fresh pot roast across the kitchen floor. And, even though the collectors may be a small, select group in the marketplace, they can normally provide the proper themes more than enough attention to allow the art to become a rare and a strong investment.

The Value of National Exposure

If you have been collecting an artist who is either locally or regionally known, and that artist has just been signed by a publisher who will market the work nationally or internationally, keep your fingers crossed. Keep in mind that just because an artist is making the big leap from local boy to national star, success isn't guaranteed. But it is a necessary step before an artist can be considered a long-term genuine investment.

Consider how many people know of an artist who is marketed locally, then consider how many more people will know of that same artist when he's marketed nationally. The increased exposure will undoubtedly lead to more collectors, and, if the edition sizes remain constant, there's an excellent chance that the demand for the artist's work will increase.

A number of artists started off as local treasures. Bev Doolittle and Robert Bateman both started off that way. Their styles were broad enough and their talent rich enough. Eventually a big-time publisher found both of them. And, they both had early prints that today are worth a fortune more than their original price.

Most artists do start off as local treasures — living on self-promotion, participating in local art shows and entering art contests. They dream of making it big and having the world appreciate their efforts. But it takes a lot of luck and hard work, not to mention incredible talent. Occasionally it does happen, and not only is it lucrative for the artist, it can quite often be lucrative for the collector as well.

The Sell Out

With most limited edition collectibles, the term "sold-out" refers to when the manufacturer is no longer producing and circulating a product. Specifically in the art world, the term means that the publisher's supply of a print has been exhausted, but it does not mean that prints are not still circulating galleries, frame shops and gift shops. When art collectors hear those magic words "sold-out," it is the first important indication that the prints may increase in price.

After a print sells out from the publisher, collectors must realize that the print is showing signs of collectibility. The print is making its way into private collections and many of those prints are undoubtedly being framed and hung for long-term enjoyment. The supply is dwindling and the rarity is increasing. Very soon, the dealer network is likely to run out of the print, in which case the only source to obtain the work will be the secondary market.

Consider what happens when a collector is looking for a work that has completely sold through to the retail clientele and is trading on the secondary market. A collector contacts a gallery and attempts to purchase the print, but finds out that the primary source for obtaining that piece (the publisher) doesn't have it anymore. The collector has two alternatives: 1) they decide not to make that specific purchase and they possibly reselect, or 2) they end up paying a premium to someone who already purchased the

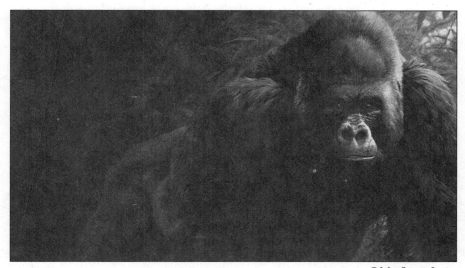

Great Britain native John Seerey-Lester has found a home in the United States and a large base of collectors drawn to his unique sense of composition. (Pictured is Seerey-Lester's "Face to Face")

print and is willing to part with the piece for a profit. The latter is what drives the investment end of the art world, and it all begins with the sell out.

Whether you are an art collector, an art investor or simply one who buys art for personal enjoyment, before your art can increase in price it must sell out.

Knowing the Value of an Edition Size

When it comes to questioning the investment potential of a print based on the quantity produced, it's important to make sure the comparisons are apples to apples. If the artist and publisher have made a wise and well thought-out decision, even sizable editions can be "fruitful" for collectors.

The theory of supply and demand dictates that if there are fewer works of a particular piece of art produced, each one should have a greater value. However, some artists will have greater followings and some subjects will necessitate more prints to accommodate the number of interested collectors. Consider whether it's more logical for a publisher to produce 500 prints by a new artist with a collector base of 200 people; or is it more logical for a publisher to produce 25,000 prints to accommodate an internationally known artist's collector base of 100,000 people? And, is it more logical for a publisher to produce 1000 prints of any old rowboat or 1000 prints of The Titanic? The edition size is all relative to the situation.

But, there are other things that collectors must consider when they think an edition size is too large. If it was too small, they may not have had

a chance at owning the work. The outstanding image that they are drooling over, which could have provided them with a lifetime of enjoyment, might have sold-out before there was an opportunity for them to even know it existed. Thanks to the larger edition size, they can now own the image for eternity if they desire. Furthermore, this additional quantity produced can give the artist tremendous exposure, which can give the market an impetus to grow and make past and future editions more valuable.

A study of the art market will reveal that many works of art produced in large editions — such as time-limited edition prints — have shown exceptional resale value. Take Robert Bateman's "Midnight Black Wolf" for example. The publisher issued 25,352 at $325 and they are currently trading for upwards of $2,000. And 8,544 copies of Bev Doolittle's "The Forest Has Eyes" were issued for $175 and they currently sell for more than $5,000. Would these prints be worth more if they were produced in editions of 500 or 1,000 prints?

A legitimate case can be made that a large edition spawns activity and exposure in the marketplace. Consider what happens when an excited and proud collector takes home a new print. It's likely that he shows it to a number of friends and there's a possibility that one or more of the friends will find it equally pleasing and want to own a copy as well, which increases the demand. Furthermore, the more people given an opportunity to show off a piece of art will often translate into more people wanting it.

Of course there will always be the cynics who think it's all a matter of dollars and cents. No one can argue that art is a business and larger editions generally mean more revenue for the artist and publisher. But, most reputable publishers know that in order to realize long-term success for an artist, they must keep the collectors satisfied. It's of utmost importance. Collectors need to trust that edition sizes have been determined correctly until it's proven otherwise by failure in the marketplace. The artists and publishers who make the decisions have much more at stake than the collectors. And, in most cases they do make the correct edition size decisions.

The Lower Number Misconception

One of the biggest misconceptions in the world of offset lithography is that the lower the print number, the more valuable the print must be. Today print numbers are no more than serial numbers that distinguish one print from another.

In the early days of original printmaking the earliest prints in an edition had greater quality. As subsequent prints were made, the quality lessened as the plates used to make the prints wore down or became dirty from use.

With offset lithography, the mechanics of production allow for an edition to be proofed and set before the run commences, and all the prints released are exact duplicates of each other. When artists sign their prints, they have no reason to be concerned with what one to designate No. 1. All

the prints are the same.

Imagine a printing press with a thick stack of sheets of blank paper being inserted on one end. Each piece of paper works its way into the machine so the inks can be applied, then the piece of paper comes out the other end of the machine with a printed design. The first print completed falls onto the guides and is covered by the next, and so on. So in reality, the print that ends up on top is most likely the last one printed, rather than the first. When the artist signs and numbers a print run, they generally start from the top of the stack and assign it a Number 1, while actually it was the last one to come off the machine.

So, you can see there is no importance to owning a low number. There is more of an advantage to having a special number like Number 100 or Number 1000, than owning a low number like 28.

The most valuable number in the long run is the one kept in the best condition by the collector. And you can control that yourself, by taking precautions in the handling, framing and displaying of your art.

An Artist's Personal Touch

Have you ever stood in line to meet a famous person — a movie star, a ballplayer or a politician — and had them inscribe on a book, ball or a piece of scrap paper a warm personal greeting like, "To John, Best Wishes"? What a special feeling to have them write something so specific just for you. But did you do it because you thought it would add value to the item? Did you ever consider whether it would have additional value to anyone besides you or others named John?

A limited edition print connoisseur will never allow the artist to add names, dates, or other non-generic words to a print for fear it might limit the number of people interested in the work in the future. If they do have the piece personalized it will include only neutral words — "best wishes," the title (if it doesn't already appear), or a simplistic message relevant to the piece like, "Art is a many splendored thing" or "May your star shine bright." The latter phrase is appropriate for a painting of outer space, but inappropriate for a work of wildlife art by Robert Bateman.

It is fact that any message with a specific meaning, which was not originally on a print, can be extremely detrimental to potential resale. Consider something as trivial as the date. What if the date has no meaning to the person who might be interested in buying the piece from you? Perhaps it's your defense that you have no intention of ever selling the piece.

Even if your intention today is to keep the work forever, your taste may change or perhaps you might be tempted to sell if the piece was worth enough money. Everything has its price you know. Add enough zeros and everything is for sale.

Be very careful if you decide to have a print personalized. Try to guide the artist by asking them what they intend to write before you allow them to actually begin the personalization process. There is nothing more dis-heartening than seeing a prized print that has lost its resale potential because of a few simple words.

Most offset lithographic prints come in custom-made protective envelopes.
(Photo by Alan Brown)

The Value of the Print Envelope

Most limited edition offset prints come with a protective envelope made of an acid-free material. This envelope not only protects the print, but it also helps make a glorious presentation when the consumer unfolds the cover and sees the print unveiled before his eyes. But how important is the envelope to the investment value of the print? Is the print worth less if it's no longer around?

Most print envelopes end up folded and thrown in the trash bin after the print is framed. But occasionally, a collector will come along who feels that the envelope does have value. In reality, the envelope is worth the paper it's printed on. It is often replaceable, unlimited and quickly bent up or scarred from handling.

The best advice is to keep envelopes that have unique printed information or designs on them. But if you decide not to keep the envelope, it's not a major problem. The lost value is very minimal. Most serious collectors feel when purchasing an art print that the value is not in the envelope, the authenticity or the biography. The value is the art.

Matched Number Print Collections

When you get up in the morning and select your wardrobe for the day, you're conscious — or at least you should be — of whether the clothes you're wearing match. You don't normally want to wear a blue tie with a

© Tom duBois

Collecting each release from Tom duBois' series featuring Noah's Ark has become a passion with many collectors. (Pictured is duBois' "The Invitation")

green shirt or pull up one brown sock and the other black. In the art world, it's not much different.

When a print is released as part of a matching collection (e.g. the annual Federal Duck Stamp Print or Jim Daly's series of works about Ellis Island), collectors may know ahead of time that they'll have the opportunity to adorn their walls with what will be a series of prints. These prints are often issued at varying intervals and they all have some common, matching factor. When this type of opportunity arises, if you intend to purchase each one, it's always a good idea to request matching print numbers — each one having the same sequential number. For example, 324 of 950.

By making sure they match, the collector puts himself in a desirable resale position. Should there be a buyer looking for the set, they'll be one of the few able to offer it. On the other hand, should they not be able to find a buyer interested in the set as a whole, they can always still break up the series. Either way, it's a win-win situation.

Experience does show, however, that as a collection gets bigger and bigger the opportunity to sell it as a group diminishes. The reason is purely economical. If the series has only four pictures each valued at an average of $200, for example, the cost of the set is about $800. But if the set has 20 pictures in the collection, then the cost is approximately $4000 — quite prohibitive for some people.

There is another way to create a matched set, though it's a little less precise and a little more fanatical: Assemble a collection of work by one specific artist. Occasionally a collector comes along who enjoys an artist's work so much that he's intent on purchasing each and every print the artist releases. Even though the releases might not be part of a designated collection, they're part of a different type of collection — the collection of art by

artist XYZ. The same variables related to the regular matching series come into play. If an equally fanatical buyer can be found, the collector has a market advantage.

The bottom line with any art collecting strategy remains that if you like it and can afford it, buy it. And if you don't like it, don't buy it. But if you plan to buy almost every print by an artist or every print in a series, talk to your gallery and see if you can take your collection to this unique level. There are rarely additional costs associated with doing so, yet there may be an additional benefit if the right situation arises when you decide to sell.

Purchasing a Print in Multiple

People who consider themselves art investors might occasionally have a strong feeling that a print will increase in value, and they'll arrange to buy more than one copy of the piece. They might put one piece on the wall and stick another under the bed or in the closet. They might buy a dozen or more with investment in mind, and put them all in storage in anticipation of the day they offer them back to the marketplace for a hefty profit.

This type of purchasing can be dangerous, both to the marketplace and to the investor's pocketbook. Consider the reason: From the marketplace's standpoint, it's important that prices are driven upward because of a lack of supply. If too many collectors are speculating on a piece — holding them with the idea of selling at a later time — it can create the illusion that the piece has sold well and is extremely rare, which is false. The marketplace could appear dry; meanwhile investors' storage closets are heaping with hoarded prints. In theory, the market could dry up completely, forcing the prices to jump sky high. Then at some future time, the market could become flooded with the piece when investors return to the market ready to sell at the newly inflated price. This new flood can cause the prices to drop dramatically.

The other problem with buying in multiple is it poses a potential risk for the collector. Normally, if a collector buys a piece of art and it doesn't increase in value, the collector still has an enjoyable piece of art to decorate their home or office. But, a collector speculating on a single image and buying it in multiple is taking a great risk, since it's doubtful they'll want to decorate their home or office with dozens of the same print if the investment flops.

For the collector with money burning a hole in her pocket, it might be wiser to select a variety of potentially strong prints. Create a portfolio that mixes a number of great pieces by a few special artists. This way, if one print does legitimately well and another one doesn't, there's still an opportunity to make a profit by selling off the strong one. And best of all, you'll receive more enjoyment and satisfaction from two or three different pieces of art rather than one piece that hangs in every room of your house.

Promotion, Promotion, Promotion

Ask a group of real estate agents to name the most important consideration when purchasing a piece of property for investment and they'll tell

you — location, location, location. Ask a group of art dealers or knowledgeable collectors what the most important consideration is when buying art as an investment and they'll tell you — promotion, promotion, promotion.

To best illustrate the importance of promotion, consider this well-known analogy: If a tree falls in a forest and no one hears it, does it make any sound? Well, if one person hears the tree fall, it's less likely to be made into firewood than if the entire population of Wisconsin were to hear the crack and thud. The more people that hear it, the more people they'll tell and, consequently, the quicker someone with a chainsaw will show up to turn the tree into kindling.

Now consider the tree that no one hears fall. Let's suppose this tree is the biggest, best firewood tree ever to fall. Suppose this tree is so big that it has the potential to warm the state of Alaska for an entire winter. What are the chances that someone will cut it into firewood? Well since no one heard the fall, it's possible it won't be discovered at all. It could become petrified wood before someone chops it up.

There are many intangibles that help determine the success of an artist, such as the uniqueness of their composition and the beauty of their work. But no matter what they have going for them, they need an element of promotion to alert the world that they exist.

There are many talented artists in the world, but only a select few are ever given the opportunity to sign with a major publisher and gain national promotion. And the fact is, it's easier to sell a thousand pieces when you have a thousand people who know you exist. Promotion creates exposure and opportunity for the artist and the collector.

From a resale standpoint, recognize the value of a strongly promoted artist. If you are going to gamble on an artist as an investment, take time to think about where they are going promotionally. Make sure they're either receiving strong promotion or they at least know the value of receiving it. Make sure they can at least see the forest from the trees.

Reaching the Price Peak

Do you remember hearing stories from your grandparents about how they would walk five miles to school and work for 25 cents an hour? And, aren't you looking forward to rubbing it in your grandchildren's faces the same way by telling them that you can remember when candy bars were only a nickel? Perhaps you'll also tell them about the print you could have bought for $100 that today sells for $5000. If you only had a crystal ball, right? Then, you wouldn't have had to become the Psychic Hotline's best customer.

Well, don't feel bad. There was no way you could have known. Nearly every expert in the art world has made an incorrect prediction more than a few times about the potential future value of a limited edition print.

It seems the more we learn about predicting the investment potential of limited edition offset art prints, the more we realize that we still know very little. The industry is extremely young — only a little more than 35 years old today — and it's the fastest growing segment of the art world. The

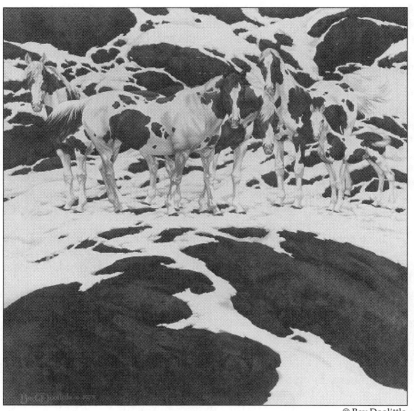

Bev Doolittle's limited-edition offset lithographic print "Pintos" is valued today at near $10,000.

highest valued offset prints are now reaching the $10,000 mark, and these are prints that were released for less than $200. Only 10 years ago, the highest valued offset prints were valued at less than $5,000. So, in the past 10 years the upper cusp of the market has more than doubled. At that rate, can you imagine where it might be in another 10 years?

Two of the most well-known $10,000 prints of today are from paintings by camouflage artist Bev Doolittle: "Pintos" and "Woodland Encounter." Both were released in the early 1980s, less than 20 years ago, for $80 and $150 respectively. As their market value rose over the past two decades, most experts felt that the prints had peaked near $3,000, then $5,000, then $7,500, but they kept climbing and selling for higher and higher prices as Doolittle's popularity grew. Today, experts continue to say that the prices of these prints have peaked. Perhaps they have, but on the other hand, maybe they haven't. Only time will tell. As the offset lithograph gains the confidence of collectors, there's no reason to think that there will be a limit.

14

The Artist Proof

The Misunderstood Value of Artist Proofs

One of the most misunderstood concepts in the world of offset lithography is the artist proof. Some people erroneously believe that artist proofs are the first pieces to come off the press. Others believe that the artist proofs are select prints chosen by the artist because they exhibit higher quality than the rest of the edition. But these are simply "old wives' tales." Each artist proof is no different than the regular, numbered prints within the edition except for its special numbering and its higher issue price. The artist proofs are not better and they are not the first to be made.

In most cases, the issue price of an artist proof ranges from a flat 20 percent more than the regular part of the edition to exactly twice the price. But history shows that when a print reaches sold-out status and the trading begins on the secondary market, an artist proof will bring only a minimal amount more. In fact, history shows that as time goes on, the artist proof will bring exactly the same amount as any regularly numbered prints within the edition.

For example, let's assume that a print is released for $100 and the artist proof for $120 (20 percent more). If it's a popular print, one day the print might be sold-out and trading on the secondary market for $1,000. Theoretically, one would expect the artist proof to be selling for at least $1,200 (also 20 percent more), but it rarely occurs that way. In fact in most cases it will probably be valued at about $1,020 — just the same $20 more that it cost initially. Was it a good investment? No. There was no additional return on the extra $20 it cost to obtain it.

A collector should only buy an artist proof when it can be obtained for the same price as the regular part of the edition. Never pay extra for special numbering or selective positioning. A special number might be a "kick" to own, but from an investment standpoint, the additional value is practically nonexistent.

As evidence of the demand, most of the time the regularly numbered prints tend to sell out before the artist proofs. This is further evidence that the artist proof is less desirable. It's very common to see 1,000 numbered prints sell out before 76 artist proofs — indicating that the demand for the regularly numbered prints is 14 times greater than that of the artist proofs.

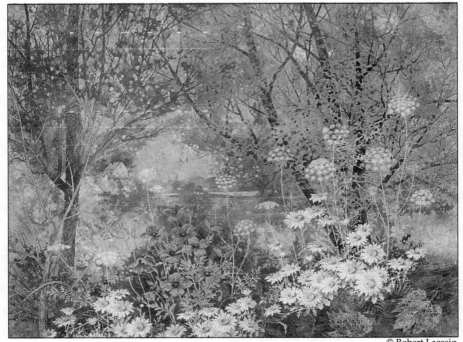

Robert Laessig rose through the ranks of American Greetings to become one of the nation's most respected floral landscape artists. (Pictured is Laessig's Misty Marsh)

So when should a collector buy an artist proof? Since collectors tend to purchase the numbered prints first and the artist proofs last, there is normally a short period of time after the regular edition sells out when the artist proofs are still available from the publisher for their original issue price. If the regular edition is demanding a greater price than the artist proof on the secondary market, then this would be one of the rare instances when buying the proof would be the wisest decision. Furthermore, if for any reason you were offered an artist proof for the same price or very close to the same price as the regular part of the edition, it would be prudent to purchase it, since it is considered a smaller and slightly more valuable part of the edition. But, don't mistakenly buy the artist proof because you're convinced it's a better investment than the rest of the edition. History shows it's not.

To Number or Not to Number

The practice of producing artist proofs of offset prints grew from a tradition that existed in original printmaking methods — long before the offset print movement. The initial intention with the proofs was to divide them up between the artist and publisher, and donate a few copies to worthy institutions and charitable causes.

John Weiss' dog, Maggie, and their 90-year-old next-door neighbor, Grady, made perfect models for this painting known as "New Friends."

During those early days, most proofs were just designated "A/P" or the artist scripted "artist proof" on the border of the print by hand during the signing process. No numbering was included, though the quantities were documented and authenticated. However, as the offset print got more and more popular, it became evident that the proofs could and should be sold. This led to the numbering being added in an effort to more clearly authenticate the number of proofs produced. This numbering system for proofs is still used today and denoted with a number and then the A/P designation. For example, "xx/yy A/P" or "xx/yy artist proof." Either way is acceptable.

By numbering the proofs, it eliminated any desire by unscrupulous artists and publishers to offer more proofs than stated. And it kept them from the temptation, and eliminated their ability, to issue prints indefinitely. Today the standard practice is to number the proofs.

Buying the Artist Proof as a Form of Insurance

Buying artist proofs is similar to buying insurance. You're never really sure if you're going to need it but by having it you feel more comfortable and you can sleep better at night. Hey, it's only money, right?

But, if there is no difference in quality and the proofs don't increase in value proportionally to the prints from the rest of the edition, when should a collector buy them? The answer lies in the sales advantage the owner of an artist proof will have over someone with a regular print.

The prospective buyer will weigh the options — artist proof or regular? He'll note that even though the prints are the same price today or the proof is only priced for a pittance more, the owner of the proof most likely did pay more for it, and he'll also note that the marketplace values it slightly higher. He'll also note that the proof is from a more exclusive, smaller portion of the edition. If the price of the two available prints is similar, and the condition is the same (preferably mint), the buyer would have an easy choice to make. He'd take the artist proof, leaving the owner of the regular edition print searching for another buyer.

If you are truly buying works of art with the intention of reselling them in the future, the artist proof can provide you with a very slight resale advantage. But if you're buying works that you like with the intention of keeping them forever, save your pennies. In fact, why not set aside the extra cents you would have spent on proofs, then, when the piggy bank gets full, buy yourself another print.

15

Gallery Etiquette

Negotiating the Best Price

We've all been taught to never buy a car for the sticker price and to always attempt to negotiate a better deal on furniture and appliances. Most of the time there's some room to work the salesperson. He's probably on commission and knows that if he sells the item to you, more than likely he can come up with another one to sell to the next guy. The salesman's biggest fear is that you'll take your business to a competitor, in which case he'll end up making nothing. But limited edition artwork is much different. Because a predetermined number of prints are produced, the seller isn't always able to replace the piece of art. For this reason most galleries have a policy of holding their prices firm.

But there's another reason that furniture and cars are negotiable. From the moment you take them home, they begin depreciating. Oh sure, if you have a rare mint condition early model automobile, there can be significant appreciation, but rarely does a new vehicle come off the lot and have even the slightest potential to increase in price. By the time you sell it you're lucky to get half of what you paid for it. Fine art is much different. Due to the limited quantity produced, art can become rare and collectible within a short period of time — sometimes before it even leaves the gallery. Art is a product with potential to appreciate — quite the opposite of cars and refrigerators.

There's nothing wrong with asking the salesperson whether a price is firm, but if the answer is no, be respectful of the policy. If the cost is greater than you can justify, ask the salesperson for help finding a less-expensive piece.

It's best not to "monkey around" when you find the perfect picture. (Photo courtesy of Gallery One, Mentor, Ohio)

Most galleries allow framed works of art to be taken home on a trial basis. (Photo by Alan Brown)

Standard Trial and Return Policies

Art is meant for long-term enjoyment, so most galleries encourage collectors to try works of art in their homes or offices before making a final decision. Due to differences in lighting, and the importance of colors complementing the decor, most galleries allow framed works of art to be returned for a full refund for as long as one week.

As for unframed prints, they're generally a different story. Rarely will a gallery allow one to leave the store premises with any sort of guarantee for a refund or exchange, and rightfully so. From an investment standpoint condition is everything. Even the most careful handling can result in a bent corner or a ding that inevitably devalues the work of art. Many galleries will offer to frame an unframed work and then let a customer try it in their home. By doing so, the risks are greatly reduced for both the gallery and the collector.

Most galleries also offer an exchange plan for framed art purchases, often as long as one year, so that clients who decide to redecorate or who tire of an image have the opportunity to select a new print, as long as the work is still in perfect condition. And, most works of art that are merely hung on the wall do remain perfect.

The reason galleries often use a long-term exchange plan is because they know that most art will hold its value or increase in price. If a work is traded in that has increased in price, normally the gallery will only offer the collector the price of their initial investment in trade; however, the gallery will mark the print up to the current value. It is very good strategy for the gallery, and the customer can't complain; they used the work for a period of time without having to pay a rental or restocking fee, and now they can select another work to suit their current interests.

Most reputable galleries know that art is a personal thing, and that a collector who isn't happy with their art probably won't return to do additional art buying. Therefore, they tend to work very hard to accommodate their collectors with exchange and return programs to add to art collectors' satisfaction and enjoyment.

Getting the Most Out of the Service

Just like any other business that wants your patronage, a good art gallery must offer a varied selection of products that suit your tastes, and competitive prices that interest your pocketbook. But what ultimately distinguishes the good galleries from the great are the services they can offer the collector.

Viewing and selecting art is a very personal experience. The right piece of art has the ability to take a dull, quiet room and make it colorful and exciting. It can make a day at the office more palatable and make home life more relaxing. The right piece of art can bring pride, self-esteem and happiness to the viewer simply by its presence, and a good service-oriented gallery knows this. They'll take the time to listen to your concerns and they'll take the time to get to know you better.

Galleries should recognize how important and personal art is to people. They need to be willing to bring pictures out to the home or office and offer professional advice to help the buyer decide what pieces meet a specific need best. They must be willing to let the buyer live with the art for a few days before making a final decision. And, they need to be willing to hang the selections on site to assure the art is securely attached to the wall and placed at the right level for maximum enjoyment.

A good gallery can make the art collecting experience educational and fun by bringing in artists for personal appearances, and quite often they'll have the artist show slides or speak about their inspirations and their ideas. They'll provide a time for you to meet the artist, shake their hand and have them personalize a favorite work. Furthermore, a good gallery will provide a selection of books and videos, so even when the artist isn't in attendance you can still get to know him better.

Above all, a good gallery needs to make you feel comfortable and not pressured if you just want to enjoy a stroll through their store to relax and look at some inspiring art pieces. And, they must be willing to stand behind the workmanship of their art and framing for a lifetime should you decide to make a purchase. If you ever decide to sell a work of art that you purchased from them, they need to have an in-store resale program in place or the ability to refer you to someone who does.

If you are looking for a sold-out work, a good gallery needs to have a secondary market art resource available to aid you in your search. They also need to offer state-of-the-art conservation framing and a wide selection of frame and mat choices to match your décor. And, after you make your purchase, a good gallery needs to keep you informed as new releases by your favorite artists are issued. They need to keep you abreast of any exciting news about the artist that might make your art purchasing more enjoyable.

The way a gallery displays their unframed art can tell you a lot about the care they'll take to make sure your prints remain in mint condition. (Photo by Alan Brown)

Whether you are a one-time buyer or a regular collector, the services that a good gallery offers can make the art buying experience a joyful and exciting time. Look for a gallery that makes you feel comfortable and gives you the personal attention you deserve.

Telemarketing Art

Have you ever had your dinner interrupted by a phone solicitor who had a deal for you so swell that "you can't afford to pass it up"? If so, I hope you haven't fallen for the scam. Some of these companies make their money by convincing folks that they've won a very valuable work of art. Congratulations! All you need to do is pick up the shipping cost, $20, and it'll be delivered within a few days. Sounds like a real deal, right? Wrong! The art isn't worth what they claim. In fact it's probably only worth the paper it's printed on. The shipping charges include a markup and that's where these companies make their money.

The scammers also occasionally fool winners by telling them that all they have to do is pick up the cost of the special framing option for $50 or $100. They claim the picture is worth hundreds of dollars so it's a small price to pay. Again, the picture isn't worth what they claim, and the charge for framing is more than enough to offset the manufacturer's cost.

If these companies call on you via the phone or the mail, just take the same approach that you would for any art purchase intended for decoration and not investment. Take a look at the work of art. If you like the image enough to want to own it, and feel the cost warrants the beauty, take them up on their offer. But don't get excited and make a mistake. You haven't won anything but a colored piece of paper.

16

Death and Taxes

When Artists Die

Many collectors often assume that when an artist dies, the value of the artist's prints will increase dramatically. In most cases, though, this simply isn't true.

In theory, the death of an artist will play a part in the supply and demand equation. Unless the artist has some ghostly ability to paint from the hereafter, production of paintings will cease. Should the artist be popular and in demand at the time of his or her death, then a mad scramble for prints is likely to ensue and an immediate increase in prices will result. But, as time goes on, the collector demand will end as the prices level and the promotion generated from new releases ends. Then what happens? Without supply of product and without collector demand, the market has no reason to get excited. The market often dies along with the artist, and subsequently, the value of the art tends to decline.

© Alan Maley

Alan Maley's family continued to issue limited edition offset prints after the artist's death. (Pictured is Maley's "Café Royale")

The art world lost a superstar when 38-year-old Stephen Lyman was tragically killed in a hiking accident in the mid-1990s. (Pictured is Lyman's "Evening Star")

The art market will always be a market of promotion. When publishers can no longer realize profitable results for themselves, they'll stop promoting. That's basic business economics. And, when the publisher runs out of inventory, the market will have lost two key players — the artist and the publisher.

If you are truly investing in the work of an artist for resale and the artist dies, be prepared to sell quickly, usually within a few months. If you choose to hold on for greater opportunity, you're likely to be very disappointed.

The Production of Prints by a Deceased Artist

Many artists paint for years before their works are put into print, creating a backlog of viable print imagery. And, should they die unexpectedly, occasionally some of that work can still be printed if the artist's family, who assumes the copyrights, agrees to sell those rights to a print publisher.

Recently the offset lithographic art world lost two very respected artists, both in their prime — Alan Maley and Stephen Lyman. Maley, known for his impressionistic portraits of turn-of-the-century regalia, owned his own publishing company, Past Impressions. Upon his death in the early 1990s, the family continued his limited edition print tradition and they still release a couple of new works every year. The releases are still numbered as before; however, the signature used is the one of Maley's wife, Pamela.

Stephen Lyman passed away in the mid-1990s in a tragic hiking accident at age 38. Known for his paintings of wildlife, mountains and campfires, Lyman is one of the most collected artists of our time. Since his death, a number of limited editions have been released by his publisher, The Greenwich Workshop, and Lyman's wife, Andrea, now signs the works on her husband's behalf.

The signature of the spouse has not always been the standard. When famed wildlife artist Ned Smith passed away, his works continued to be released with a gold replica signature. There have also been a number of instances where no prints were released after the artist's death. The decision is the family's to make, as the holder of the artist's copyright.

Charitable Prints and Tax Deductions

The use of art to raise money for nonprofit organizations has long been a tradition. Wildlife artists have been at the forefront of these generous contributions — raising millions of dollars for the World Wildlife Fund, Ducks Unlimited and National Wildlife Federation by donating a portion of the revenue generated from sales of select print purchases. The collectors often are involved in the excitement, and through advertising know that when they make a purchase it will benefit a worthy cause. But is there a tax advantage to purchasing a print advertised in this way? Unfortunately, the answer is no.

The person who ultimately makes the donation is the actual recipient of the tax break. So, if the donation was made by the artist, he'd get the deduction and if the donation was made by the publisher of the print, then they would. What it really boils down to is who signs the check written to the organization.

Bonnie Marris often brings humor into her wildlife art paintings.
(Pictured is Marris' "For the Love of Pete")

You might wonder why, if there isn't any benefit for the collector, would anyone even need to know about the donation? Well, when an artist or publisher participates in this type of program, they act as a role model, creating tremendous free publicity for worthy nonprofit groups. This publicity can often lead to additional, but unrelated donations and needed support.

17

Restoration

Knowing What Can Be Restored

Even with the most talented doctors and the most advanced technology, the patient assumes an element of risk when undergoing open-heart surgery. At any time during the operation the patient might be lost if the doctor slips with the scalpel or if some unanticipated reaction occurs. Print restoration is no different.

Some of the most common problems that art restorers face are: acid-burn, removal of tape hinges, mildew, smoke damage and rippling from humidity. Most of these can be repaired when caught early.

Acid-burn is the yellowing that occurs to a piece of paper over time. It results from the acid content in the paper not being neutralized. With art, the burn can be from the print itself or the matting, backing boards or any other acidic item used in the framing process or in the packaging. Acid-burn is treated with highly noxious chemicals. After the procedure, the chemicals are rinsed out and the print is dried. Because of the dangerous fumes that the chemicals give off, the work is done in specialized chambers and though the risks to the artwork are great, if not done properly, the risks can be greater to the technician.

Another very common problem that requires restoration is the removal of tape hinges. Though not the preferred method of attaching a print to matting, tape hinges have long been used by framers. Ideally the hinges will be made of rice paper or an acid-free cloth to reduce the risk of acid-burn. But the problem with the hinges is not normally acid-burn anyway. The problem is the removal of the adhesive that is used to attach the hinges to the art paper. If you've ever tried to remove a piece of tape from a piece of paper, you know that it takes part of the paper with it, leaving a permanent abrasion. The art restorer's job is to remove the adhesive without leaving a mark.

If the adhesive has been rolled or pressed into the paper, the job is much tougher. Imagine trying to lift a mustard stain out of the fibers of a shirt. It's similar to the way a restorer uses delicate solvents to loosen the tape and carefully remove the adhesive.

Art restorers can also remove and kill off the mildew that can appear if a print is exposed to excessive moisture. One way to eliminate it is to put the work in sunlight, but that can lead to fading of the inks and warping of the paper. Generally, a restorer will try to lift off the mildew with a kneaded eraser then treat the print with chemicals.

Paul Landry's soft, impressionistic style is perfect for collectors fond of traditional or contemporary art.

Another restorable problem is smoke damage from a fire or extensive exposure to cigarette or cigar smoke, which can leave a coating of tar on the print. To fix the problem, a restorer will normally air the print out and use a pounce bag to clean the surface.

Restorers also can improve, and sometimes fully repair, prints that are rippling from humidity. To get the print to flatten out again, moisture, pressure and weight are used to help the fibers realign themselves. However, if the stretching is severe or prolonged, then the ripples can become permanent and they cannot be removed completely.

A professional restorer can fix many other problems and do general cleaning. Hopefully, by using reasonable care you'll never need an art restorer. However, it's nice to know that if a problem does arise, all is not lost if you catch it early and consult an expert.

Finding a Professional Restorer

To find a professional art restorer, look in the phone book under Art Services: Restoration, or call your local art gallery or museum for a referral. Expect the costs to range from $100 for a small, easy job to many hundreds of dollars depending on the severity of the problem.

If you are intent on having a piece of art restored, then it's likely a valuable piece of art or something with personal value, so the cost might not be prohibitive. However, selecting a credible restorer can be risky so always inquire about their training, experience and call a couple of references to be safe before making a print risking decision.

Restoring to Mint Condition

Many restoration projects have a much greater chance for success — removal of acid-burn, mildew and tape hinges to name a few. Other restoration projects are more risky. But even with less complicated projects, until the process is finished, nobody can know for certain if the result will be successful.

The title of Will Bullas' painting "Fowl Ball" is almost as funny as the image.

The true test is to wait until the restoration is complete and then have the print examined by a professional gallery owner. The print should be inspected front, back and sideways and if the examiner cannot tell that the print didn't just roll off the printing press, then the print can be considered once again mint.

If you have a work of art that is in need of restoration, it should be taken to a professional. A professional will test every chemical before applying it. They'll use Q-tips to test reactions to each color and they'll build from weaker chemicals up to more aggressive, riskier chemicals as necessary to achieve the desired results. The result is more dependent on the way the restorer understands and uses the chemicals than the actual gracefulness of the restorer. And, even with the best restorer, the paper and ink may play a part in the potential for a complete restoration.

Keep in mind that with most damage that is restorable, the longer you wait to restore the work, the more risk there is that the damage will become permanent. If you intend to have something restored, have it done now instead of later. You greatly increase your chance of getting a mint condition result.

In some cases, very little can be done. For instance, if you put a hole in your print, then all a restorer can do is make a patch and the condition and value will forever be less than mint.

Understanding Acid-Burn

Did you ever notice what happens to the newspaper that you leave outside for a couple of days? It turns a brownish-yellow color. That is acid-burn and it can happen to your art print if you're not careful.

Most prints today are printed on high-quality paper stock that is either acid-free or all rag. An acid-free paper is a treated paper made of wood pulp. Wood pulp is highly acidic before treatment. After the treatment, the acid content should be neutralized and the paper should remain crisp and white indefinitely. However, if there is even a trace of acid still in the paper, it can eventually revert back to its original content and begin to yellow.

All rag paper, on the other hand, is made from cotton. Cotton has no acid and it should remain crisp and white forever. The problem is that most cotton-based papers are very expensive.

There's another way that acid-burn can affect a piece of art paper. Perhaps there is an item touching the paper that is acidic — an acidic mat, protective envelope or even a piece of supporting paperwork like a biography card or the authentication papers. The acid in those items can bleed through onto the art paper and stain it.

Acid-burn can be removed, but it is a very costly, and sometimes risky, process. The best way to avoid it is to either frame the work of art using all rag matting and backing, or if the print is going to be stored unframed, do so between two pieces of all rag board.

The time it takes for acid-burn to become apparent can vary depending on the situation. Given normal care, most prints can resist acid-burn for about 10 years. However, certain elements like light can speed up the process tremendously.

18

Appraisals and Insurance

Finding an Art Appraiser

Most insurance companies like to have written appraisals of art from their clients once every one to two years. To get the appraisal, the client should start by contacting the gallery where the art was purchased. If the gallery still carries the work, they should be able to issue a written statement of the current value. If they no longer carry the work or aren't knowledgeable about current values for the artist, they should be able to refer the client directly to the artist, publisher or another gallery with more knowledge and experience.

If the gallery is providing the appraisal, the value they provide will be the dollar amount necessary to obtain the print at present. If the print is still available through the publisher, the price might not have increased at all. If the print is sold out, the gallery should be able to arrive at the current retail cost after checking their various secondary market sources.

In some cases, the gallery might not be active in the secondary market or they no longer carry the artist's work. Even so, they can probably still help by referring you to another gallery or giving you information that will enable you to contact the publisher or the artist directly. If that's a dead end, then they can often refer you to a licensed appraiser who can research the print and provide information about the value.

The going rate for an art appraiser is about $50 an hour. The average piece takes about four hours of research, so the cost will likely be around $200. You can locate an appraiser a couple of ways. Many galleries have appraisers to whom they generally refer clients, or you can look in the phone book under "Art Service: Appraisers" for an appraiser in your area.

You might want to do some of the initial legwork before contacting the appraiser. By doing so, you'll reduce the expense significantly. If possible, be prepared to provide the appraiser with a biography of the artist, including information about where the artist currently lives. You might also want to gather any brochures about the artist so the appraiser can compare your work to the artist's other works. And if possible, try to recall when and where the piece was purchased. If a sales receipt exists, that can help a lot, too. The appraiser will then use your information along with their sources to research the piece.

J.D. Challenger's unique style combines the traditional Indian warrior and a contemporary style to provide collectors with a unique blend. (Pictured is Challenger's "White Man's Medicine")

If you end up contacting an appraiser, it is advisable to locate an ASA-licensed appraiser. Their training includes a degree from a recognized institution of learning and two years of full-time appraisal experience; they must pass exams on general value theory, technical expertise and professional ethics; and must also undergo a background check of personal and professional references. If you have difficulty locating an ASA-licensed appraiser call 1-800-ASA-VALU for the names of professionals in your area.

Author and illustrator Dean Morrissey brought the "Sandman" to life in his award-winning story "Ship of Dreams," which featured a number of sought-after limited edition prints.

Getting the Most Out of Art Insurance

The fear of an art heist, like we've all seen on television and in movies, might be a little far-fetched for the average art collector to imagine. However, protecting your art from a loss due to fire, flood or an in-home accident can be very inexpensive and simple. All you normally need to do is talk with your insurance representative.

Every insurance company handles art differently, but the general rule with insurance is that any personal property is covered with a standard homeowner's policy — and this includes works of art within the home. For a greater degree of coverage, collectors can obtain a fine arts floater and "schedule" their art and collectibles (list them individually along with their corresponding replacement values).

A fine arts floater will provide even more coverage for a policy holder. For instance, there may be full coverage for the picture that falls and breaks unexpectedly. But with a standard homeowner's policy there may not be coverage for such an occurrence. Another great benefit of the floater is it generally has no deductible, while traditional homeowner's policies do.

Standard homeowner's policies cover a value of up to 50 percent of the home. In other words, for a $200,000 house, the standard homeowner policy will provide for $100,000 worth of coverage for personal property. With all the televisions, furniture, computers, etc., people own today, a complete tragedy such a fire or flood can cause individuals to often exceed their coverage very quickly.

The cost of the floater is very inexpensive. Traditionally, the cost will be about $25 per year for each $10,000 of art, which is a small price to pay for peace of mind. Take the time to sit down with your insurance representative and find out about the different options for your situation. It's a simple task and it can save you thousands of dollars.

Framer's Insurance

When a valuable print is given to a framer for professional work, the collector's personal homeowner's policy is likely not in force. The responsibility for the insurance is now the frame maker's, which may make you uncomfortable unless you are privy to your framer's insurance coverage.

To protect yourself, first call your personal insurance agent for advice and clarification. If the work is extremely valuable, your agent may want to request a letter from the framer's insurance agent specifying that your art is protected while in their care, custody and control. This same philosophy also applies if you decide to loan your work to a friend. You are probably going to find out that in most situations, you are uninsured.

If you care enough to insure the property when it's in your possession, then you should care enough to make sure you're insured when the property is in the possession of another. If you are concerned, it's always wise to take the necessary precautions, just in case something unexpected should occur.

19

Hanging and Lighting

Placing Art at the Proper Height

The most important thing to remember about placing a picture on the wall is that you want to hang it at the most comfortable height for viewing. In most cases, that means eye level. If you are hanging it over a piece of furniture, consider whether you will normally view the item while standing or while you're sitting and eye level is significantly lower.

Let's study a couple of common situations, the living room and the bedroom. If you plan to hang the picture over your sofa, then measure 6 to 8 inches above the back of the couch and that's where the bottom of the picture should be placed. If the mantle is your position of choice, then determine whether you have a standard 8-foot-high ceiling and a standard mantle 5 feet off the ground. For pictures less than 24 inches high, place it 4 to 6 inches above the mantle. If the picture is more than 24 inches high, then center the picture in the 3 feet of space remaining.

For pictures that are going over the bed, there are two different heights depending on whether you have a headboard or not. With a headboard, measure 3 to 4 inches above the headboard and that's where the bottom of the picture should be. If there is no headboard, prop a pillow up against the wall. Measure about 6 inches above the pillow and set the bottom there.

If you are placing the picture in an area where there is no furniture to guide you, hang the art with its center at the eye level of the average-height person—approximately 5 feet, 8 inches tall.

Other areas work in similar ways. Take the time to think about the furniture and the eye level. Then decide how the art will best be enjoyed. The general rule of thumb is that people tend to hang art too high. So if in doubt, hang it low.

Hanging Art Above a Fireplace

There's nothing like sitting by the fireplace on a cold winter's night, enjoying the warmth and ambiance of the flames with friends and loved ones while snowflakes fall outside. It's a magical feeling that makes the coldest days of winter more bearable. But, as much as people enjoy the mood of the moment, some fear that their precious print that hangs above the mantle could be in harm's way.

Normally, it is completely safe to hang a framed print above a fireplace. The mantel acts as a heat and smoke deflector, so the picture is in no worse danger than you are by being in the room. However, if you want to be assured that there is minimal risk of damage, watch the piece carefully for rippling from changes in humidity. And, keep an eye out for any condensation that could form on the glass. In almost all circumstances, if rippling or condensation occurs, your problems are more severe than the loss of your print. If you have wallpaper, it's probably letting loose and the wall is probably getting hot to the touch. You have a fire hazard more than a print hazard.

Another thing that can harm the print is soot from the fire. The day after you've had a fire, take a cloth and wipe off the glass. If there is soot on the rag, then you know that there is a danger of smoke damage over time. But again, if that's occurring, it's the least of your problems. If the soot is getting to the picture, then it's probably discoloring the wall and other items in the room as well.

Overall, if the fireplace has been designed well, there is nothing to fear. Since the spot over the fireplace is one of the most dramatic walls for art in most homes, hang an expensive work of art there and don't worry. Relax and enjoy the ambiance and warmth that the picture brings you all year long.

The Dangers of Smoking

We've all listened for years to the Surgeon General's warnings about cigarette smoke. It can cause heart disease, cancer and shorten lives. And, more recently we've found out that even secondhand smoke can be more dangerous than initially thought. But, secondhand smoke doesn't just affect people — it can also affect art prints and harm them terribly.

The tar from smoke leaves a sooty coating on clothes and walls, and it can leave that same type of coating on an art print. And not just prints that aren't covered with glass like fine art canvas reproductions. It can also penetrate a framed work of art through the inner edges of the frame and through the backing and dust cover. The result can be a print that smells like an ashtray and carries a yellow-brown haze over the image.

A print that has been exposed to cigarette smoke for a long period of time is often less than mint in condition. The print can sometimes be restored but it's risky and an expense that most collectors would prefer to avoid. If you are a smoker, you are not only putting yourself at risk, but you are putting your works of art at risk as well.

Hanging Art in the Bathroom

It is advised not to place artwork with value in any room that experiences harsh changes in humidity — such as a bathroom with a working shower, a basement that might not be totally dry or an attic without proper ventilation.

When a picture is hung in a bathroom with a shower, you may notice condensation on the inside of the glass from time to time. The condensation is caused by drastic changes in the temperature of the glass. What has

Alan Brown's photograph of a baboon is perfect bathroom art. (Pictured is Brown's "Pistol Pete")

happened is the inside of the glass is normal room temperature and the outside of the glass becomes another. The result is condensation. It's no different than the condensation that appears on your wall mirror when you're in the shower. In extreme cases, the condensation can appear on the actual print, but even when it only seems to be on the glass, the print could be experiencing temporary or even permanently disabling effects.

The most common side effects of humidity are rippling and mildew. The rippling is an indication that the paper has taken in moisture and is expanding. In some cases the paper will bounce back to its original flat composition; however, the more often this occurs and the longer the print stays moist and rippled, the less likely the fibers are to completely revert to their original state.

Secondly, moisture can lead to mildew. Once mildew, a living organism, forms, it will not die off on its own, and it is guaranteed to spread. In some cases it can be hidden from view for years as it grows on the back of a print; other times it can be seen from the front. To kill off the mildew, the picture needs to be taken to a restorer. Still, there is often permanent damage to the print from the mildew or from the chemicals that are used to kill it off.

If you are intent in hanging art in a bathroom with a shower, it is recommended that you use inexpensive replaceable art that is not likely to become rare and valuable. If you do decide to hang a valuable work of art in a humidity prone setting, keep an eye on it and at the first sign of trouble, move it to a safer location.

The Problem with Picture Lights

There are serious problems with using a mounted picture light directly on a print. Though most picture lights operate with incandescent bulbs, which are less damaging than fluorescent tubes, they still can lead to fading of the work. Furthermore, because they sit so close to the art and the light pyramids downward, the top portion of a picture receives more light and, if the lights are kept on regularly, the picture can eventually exhibit patterned and uneven fading. There's also the issue of heat generated from a bulb so close to a piece of art. The heat can lead to rippling of the picture or even mildew.

Most people who desire a picture light are doing so because their picture is dark. But darker pictures will pick up more glare than bright pictures and when a light is placed so close to the picture, the reflection can be more irritating to the eye than the lack of light. If you're using a picture light because your picture is dark, try changing the glass to a low-glare product instead. By eliminating or reducing the glare, an illusion of brightness can be created and hopefully you'll be satisfied enough that you won't need to use a potentially damaging mounted light.

Determining the Safest Lighting Fixture

There's no such thing as safe lighting for a picture. So, unless you plan to hang your art in a closet and never turn on the light or keep your picture packed in a box, your pictures will eventually fade.

The best and safest avenue to take is to use preventive caution. Avoid placing your art in direct sunlight where the ultraviolet rays from the sun will damage the colors permanently. Also, avoid placing a light source directly on the picture, and above all, use conservation-treated glass products.

There are three main types of lighting: fluorescent, incandescent and high-intensity discharge.

Fluorescent lighting generates ultraviolet energy and can lead to fading. The result is that the lifetimes of many art pieces are reduced considerably because of the fading these lights cause. There are some benefits to fluorescent lighting — they are very economical and provide a great deal of light — but the negatives far outweigh the positives.

Incandescent bulbs (standard or halogen floods and spots) are common with track lighting and they are preferred for lighting artwork. They must, however, be positioned far enough away from the art or the heat emitted can cause a print to ripple. The halogen lights emit a white light that'll bring out the colors in a picture better than other options. They also

John Stobart's ability to capture the force of the ocean is featured in his painting "Lightning Rounding Cape Horn."

allow for very direct spot lighting as well as broad wash lighting. Besides the heat issue, the other negative is the price. The cost of installing the track is high and the cost of the bulbs is high as well.

The other option, high intensity discharge lighting, is similar to fluorescent lighting. The only real difference is the way the light is created within the bulb. It does provide the most natural lighting possible and it is extremely efficient. The biggest negative is that it gives off the most ultra-violet light of all the options.

If you must use a light source on your art, use a low wattage incandescent halogen light and only use it when absolutely necessary. In conclusion, if you're a "bright" person you won't need to use any artificial light.

The Proper Way to Light

If you expect your picture to look exactly the same at home as it did when you saw it displayed in a gallery, it won't. An art gallery's business is dependent on making the artwork look its best and the lights used in a well-designed gallery are an integral part of the sales presentation. The lighting in a gallery is often even throughout, even though many pictures will appear better and more appealing with delicate accent lighting in your home. It can be structured to create a focus on the art and a balance

throughout a room.

In order to light a picture properly, you need to take into consideration the mood of the room. If the room is meant to be dim and reserved, then strong picture lighting will feel uncomfortable. If the room is bright and bold, then a softly lit picture might get lost. You also need to think about things like the size of the wall, the height of the ceiling and how much of a focus you want the piece of art to portray in the overall design of the room.

Consider the ceiling height for instance. If the ceiling is high, then the art may be so far away from the lights that the only way to light the picture properly is with track lighting and extensions dropped from the track to bring the lights closer to the art. If the ceiling is low, then you may want to place the lights further away from the art or the lights may appear like bullet holes on the glass.

Then there's the matter of windows and outside light sources. If you have a lot of outside light penetrating the room during the day, then you might want to consider whether you should be adding more light, or perhaps reducing the light by adding blinds. And how often will you be viewing the work at night anyway. Perhaps you can go without additional light and use that money to buy another piece of art. Every situation is different.

There is a standard formula that has been developed by the Illuminating Engineering Society of North America (IESNA) to determine placement of lighting fixtures. All you need to do is subtract 5'3" from the ceiling height and multiply the difference by 0.577. In other words, if the ceiling is 8' high, the difference is 2'7" or 31 inches. Then multiplying 31 x 0.577 = 17.887 inches or approximately 1.5 feet of recommended distance from the art to the light source. It is also recommended that the lighting fixture be placed at a 30-degree vertical angle.

If you want to consult a professional lighting designer, call the International Association of Lighting Designers (212-206-1281) for the name of an expert in your area; or stop in your local lighting store and ask for some advice. In some cases, lighting stores will have temporary lamp units that can be taken home and tried out before a final decision is made.

Finally, if you plan on using a light on a picture, make sure you have a dimmer switch installed. This way you can adjust the intensity of the lighting to best highlight the picture while having the flexibility to overcome any intangibles such as lamps, sunlight or reflected light from other areas. And, if your picture needs glass, make sure you look into the conservation glass options to help protect your picture from fading.

(Some information for this section was taken from *Décor Magazine*'s articles in their December 1996 and January 1997 issues.)

20

Copyrights

The Artist Holds the Rights

The copyright to any piece of artwork belongs to the artist unless he or she sells or assigns it to another person. Should someone wish to use an artist's image for personal or financial gain, they must get the approval of the artist or, by nature of the law, they will be infringing on the copyright and subsequently breaking the law.

An artist's copyright is considered infringed upon if someone knowingly creates another original painting of the work or reproduces an artist's work on any product (mugs, T-shirts, etc.) without the artist's approval. Copyright infringement also occurs if somebody takes images out of a book and sells them or uses any materials intended for advertising purposes for personal or financial gain.

There are a number of problems that result when a copyright is infringed upon. The first and most obvious problem is the artist receives no compensation for his ideas and creativity while others are able to use them, for free, to make a profit. It's blatant thievery.

Another problem is that in some situations, the infringement cheapens the artist's stature in the art world. An artist may think that mugs or T-shirts are low-class, and they may think those products don't provide the quality standards the artist desires. The artist has a right to approve or deny any product that uses his or her image and decide if the product warrants their endorsement.

Finally, there's the problem of saturating the marketplace with imagery — as is the risk when pages from a book are sold either framed or unframed. The artist has a right to sell copies of their work; to determine how the work will be presented; and to decide how many copies of each image the marketplace should be given. If the marketplace is given too much of a product, or given an opportunity to obtain the artist's work for too low of a price (as is the case with book imagery), it can impact the artist's future.

Because of the seriousness of copyright infringement, a number of artists and publishers have successfully sued parties that knowingly infringed on copyrights. If you ever question what your rights are to an image, contact the publisher or the artist before doing something criminal.

Tom duBois was authorized by Disney Studios to paint a series of images for use as offset lithographic prints. (Featured is duBois' "Pinocchio's Magical Adventure")

Copyright Infringement

Here's your chance to be a Good Samaritan and protect the collectibility of limited edition prints for the benefit of yourself and others. When someone infringes on a copyright or attempts to make a profit selling unauthorized images from books, calendars or brochures, they are undermining the efforts of the artists and publishers to keep the market truly limited and collectible. If you witness this type of blatant infringement, your interests would be best served to notify the publisher or the artist.

Upon notification, the publisher or artist will hopefully notify the infringing party and ask them kindly to desist from conducting further unlawful actions. In most cases, the party will claim to have had no knowledge of the law and will stop immediately. However, if the party refuses to stop or continues infringing on the copyright for any reason, the publisher or the artist is likely to file suit against the seller. In the event the seller is sued and the case goes to court, the precedent is for the artist or publisher to win the case and be awarded damages.

Your role in the matter will only take a phone call or a letter and it will help to protect the interests of art collectors, artists and publishers worldwide. If enough people take action and become Good Samaritans, then the entire industry will benefit as the marketplace will become even stronger and more lucrative for the collectors.

The Owner of the Painting and the Control of the Prints

When a collector buys an original work of art, they are not buying the copyright unless a separate agreement has been arranged, so the collector has no right to reproduce the image without the artist's approval. The copyright belongs to the artist. It is the artist's exclusive right to determine if the image should be printed.

In many cases, artists make a transparency of a work of art before selling it for record-keeping purposes, or just in case they decide to make the image into a print. If it's a high-enough quality transparency, then that's all the publisher and printer need to produce the print. However, if the artist doesn't make a photographic transparency before selling the work, or if there is a problem with the quality of the transparency, then the owner of the painting may be asked to lend the piece for that purpose.

In reality, if the owner is asked to release the work for print production, the artist can't force them to do so. Perhaps the collector lost track of the piece, it was stolen, or maybe it was destroyed by fire or other tragic event. Then, of course, it could not be provided as requested. And, in cases where a collector doesn't want the piece to be printed, the collector can simply refuse if the artist or gallery did not specify that they might need to borrow it.

The fact is when a print of an original work is made, the value of the original art increases in price tremendously. Consider how many people would normally know that an original exists — the friends of the painting's owner who have visited the location where the painting hangs, the people who saw the painting at the artist's studio while it was under creation, and perhaps the visitors to the gallery where the painting hung before its purchase.

Then consider how many people would know that a painting exists if there was an edition of prints distributed to the masses of art collectors and their friends who frequent galleries and collectors' homes where the prints might be displayed. It's a fact. If more people know about an original painting's existence, more people may want to own it. The more people who want to own it, the more value it has. It's simple supply and demand.

When a collector agrees to lend a painting to an artist or publisher for print production, there generally aren't any expenses incurred by them. Any expenses incurred to make the print are almost always paid for by the publisher. The owner's only expense is a little inconvenience. And, as a token of appreciation for the time and inconvenience that an owner must endure while their painting was being printed, most publishers will give the painting's owner five to twelve of the prints produced. In some cases, the total value of these prints can be as much as the painting cost.

Insight Into the Date

As the creators of an image, artists are the holder of the copyright. They retain that right unless they legally assign it to someone else, giving this other person the right to own it, borrow it or share it. According to The Copyright Act of 1976, the artist is permitted to affix the copyright symbol

"©" on the front or the back of their original art, along with their name and the year of the work's first publication. In other words, the date it was first seen by the public. It is not mandatory on original art pieces to include the date; however, most artists do follow this procedure — more as a tradition in the art world than an understanding of the law.

Robert Bateman's "Descending Shadows" combines the most collected wildlife artist of this generation with the number one wildlife art subject — wolves.

Should an artist not put their name, ©, or date on the work of art, they still retain the copyright if the work is truly theirs. However, this can open the door for legal dispute and confusion.

When an artist does include a date on an original work of art, it should be the date that the work was completed. Some artists include it not for copyright reasons, but to provide themselves and the public with a history of their efforts. When a work becomes a print, that date is replicated in the process. However, if the print is not released during the same year as the original was painted, then the date can sometimes be confusing to collectors who think it refers to the date of the print's release. It merely indicates when the original art was painted.

Knowing when a print was published can sometimes offer insight into the print's collectibility. A print that has been out for a number of years and hasn't climbed much in price is showing a lack of investment potential. This doesn't mean that it won't become collectible at some time in the future, but it is an indication that the number of prints in the marketplace to date has been higher than the demand. This is seen with prints from large and small editions. It's all relative to the situation. Sometimes in the art world 100 prints is too many and other times 10,000 isn't enough.

If you care to know when a print was published, often on the very bottom of the print's border or on the edge of the image is a small tag line with the name of the publisher, the copyright symbol (©) and a date. Ideally, this should appear on all prints. It is an indication that the artist has assigned rights to the publisher to copy the original artwork. Should it not appear, it doesn't necessarily mean the publisher didn't have the right to do the print. However, it becomes clearer in the eyes of the law when it does appear.

(This section is based on the author's interpretation of information gathered through the years. It is advised that any artist, collector or publisher should consult their own legal counsel before formulating any opinions regarding copyright information.)

21

Authentications

The Importance of Authentication

With many limited edition prints, a certificate of authenticity is included that states the title, publisher, edition size, year of release and other facts about the piece. Sometimes this paper has a space for the corresponding print number and other times it's created in a generic format with one version replicated to work for the entire run.

The importance of this paperwork has become more dependent on each publisher's philosophy than anything else. The publishers that issue the traditional generic certificates of authenticity — those without specific print numbers — do so with the idea that the best authentication you can have is a sales receipt from a well-known, reputable gallery. And, they're right. They created their authenticity to answer some of the basic questions about a print's production method, quantity of prints made and its year of issue. These generic certificates have no perceived value.

Other publishers take a different attitude toward the authenticity. They screen or have professionally typed each print's number onto each individual authentication, providing a unique document for every individual print. In these cases, the authenticity paperwork has a perceived value.

Collectors must always remember that they are buying the art and not the paperwork that comes with it. The purpose of the paperwork is to guarantee the piece is authentic when in reality, just because a certificate of authenticity exists, there is no surety. If the print isn't authentic, the certificates are the easiest part of the process to forge. Forging the high quality four-or more-colored print images would be the tough part. And, if someone is intent on forging a print, they'd probably be wise enough to be able to make certificates of authenticity, too. In reality, there are no known cases of forgery that have occurred in the world of offset lithography. So collectors should feel comfortable and trusting.

It's still best to keep all the paperwork that comes with your print including an original sales receipt. This way if you go to sell your precious work of art, you'll be prepared to provide any item that the buyer might feel is of value. But, if you misplace your paperwork or, by chance, your purchase didn't come with any, it's not a big deal. The most important element that you need for authentication purposes will always remain the art.

The Publisher's Seal of Authenticity

As another form of authentication, various publishers have moved to using an embossing or a printed design on the art paper. The design used often duplicates the company's or artist's logo and it can be found on the bottom edge below the image. In most cases, the placement is strategically placed so matting can cover it and prevent it from detracting from the image.

This process of authentication is more common in original prints today than in offset lithographs; however, as the offset industry continues to grow, it is likely to become more and more prevalent. The hope is that this type of unique enhancement will not only deter forgeries, but make them easier to identify as well.

22

A Few Other Things

Collector Societies

Collector societies have long been a tradition in the collectibles world, and they are becoming more and more prevalent in the offset lithographic arena as well. Through these societies, collectors can keep informed of new releases and artist appearances, as well as information about the families of the artists, their interests and their inspirations.

There is generally a fee to join the society, but the benefits are tremendous. Most artists offer special exclusive releases for their members, discounts and special, members-only events. Ask your preferred gallery if your favorite artist has a collector's society in operation. If they do, spend the $30 to $50 to join and start raking in the benefits.

The New Technology: Giclee Prints

Giclee (pronounced zhee-clay) is the newest printmaking phenomenon. The technique uses state-of-the-art computer technology in combination with a high-end, inkjet printing system to create near-photographic quality reproductions of original art pieces. Most experts feel the process produces prints that are far superior to offset lithographic prints. However, there is great concern about the longevity of the inks used. Recent tests indicate that the inks have a lifetime of 15 to 30 years under normal circumstances. Under normal circumstances, the inks used to make an offset lithographic print can last a lifetime.

The process is slowly earning the support of art critics, artists and publishers, and a number of prints have already been released using this process. For now the cost of a Giclee print is about twice the price of what a similar offset lithograph might sell for.

Duck Stamps

The birth of the stamp print began in 1934 when Congress passed the Federal Duck Stamp Act, which required hunters to pay for a license that would raise funds for wildlife habitat — specifically waterfowl. Within just a few years, it became a tradition to create stamps and companion prints. The images used on the stamp were chosen from those done by a large number of contestants who would compete for this, one of our nation's greatest honors for an artist.

Since its infancy, philatelic collectors have supported the Federal Duck Stamp program, and in the past few decades, with the growth of the offset lithograph, art collectors also have jumped on the bandwagon. By supporting the duck stamp movement, collectors have an opportunity to make a donation to conservation and, at the same time, obtain a quality piece of art to frame and enjoy, or perhaps invest in.

In the past couple of decades, major limited edition offset publishers have joined in an effort to build conservation awareness by creating other stamp programs to raise funds. Today, there are turkey stamps, quail stamps, trout stamps and nearly every state has a duck stamp program.

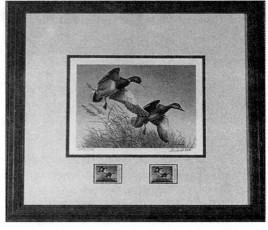

© Maynard Reece

Duck Stamp Prints have raised millions of dollars for conservation. (Pictured is Maynard Reece's National Fish and Wildlife Print "Autumn Wings – Mallards")

Perhaps because of the multitude of programs available today, the collectibility of stamp prints is not what it used to be. Rarely does a stamp print become a great investment anymore. However, for those who enjoy doing something for conservation and those who find enjoyment in an excellent piece of waterfowl art, stamp prints are an affordable way to participate.

The standard way to purchase a stamp print is to buy the limited edition print, one mint condition stamp and one artist-signed stamp. The standard framing includes all three items displayed in one frame with three openings.

Overall, the credit for the success of the stamp print movement can only be attributed to the caliber of artists painting representational wildlife art and the number of people interested in supporting environmentally conscious programs.

Licensed Products

Over the past few years, offset lithographic print artists have become very sought-after for licensed products — calendars, posters, puzzles, figurines and the like. As this trend continues, how will it affect the value of the limited edition artwork that collectors have invested their hard-earned money in?

Licensing is just another form of promotion. When an artist does a figurine for instance, it creates the potential of attracting a new collector

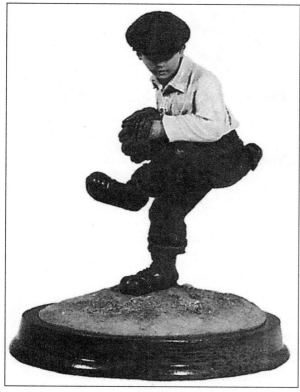

Jim Daly's figurines literally and figuratively have taken his art to a new dimension. (Pictured is Daly's "The Wind Up.")

© Jim Daly

who might otherwise not know of the artist's existence. Remember, not every figurine collector has ever visited an art gallery or been exposed to the art that inspired the product. But, through the magic of licensing, more people will inevitably become new print collectors. And the more interest in the prints, the greater the demand and the greater the potential for the prints to become more valuable and sought-after.

If you're a fan of an artist's work, then enjoy the trend to license products. In the next few years, you're going to see wallpaper, blankets, furniture and movies all based on the art of offset lithographic print artists. What this proves is that the offset lithographic art movement is gaining even more supporters and your investment is becoming even more secure. Congratulations!

© James C. Christensen

James C. Christensen's art can be found on prints, figurines, ties, scarves, note cards and even jigsaw puzzles. (Pictured is Christensen's "The Candleman" puzzle)

23

The State of the Art

Leading Publishers of Offset Lithographic Art

The Greenwich Workshop
Founded in 1972 in Greenwich, Conn., by David Usher and Fred Schlutow, The Greenwich Workshop — now based in Trumbull, Conn., — has long been respected as one of North America's leading offset lithographic publishers.

J. Fenwick Lansdowne and Peter Parnall were the first two artists to join the company that today has nearly 30 artists and publishes about 100 new prints each year. Eventually the company added the most prominent Western artists of our time: Howard Terpning, Frank McCarthy, James Bama and camouflage phenomenon Bev Doolittle.

As the company grew it became known as the most innovative publisher of this era. Usher is credited with establishing the "commission print," "art in music," and for bringing fantasy art to the forefront of the industry.

Today the company features artists in nearly every major genre: Western, Wildlife, Landscape, Aviation, Fantasy, Floral, Maritime, Ethnic Art and more. The artists associated with The Greenwich Workshop include James Bama, James Christensen, Bev Doolittle, James Gurney, Stephen Lyman, Bonnie Marris, Frank McCarthy, William Phillips, Howard Terpning, John Weiss and others.

The Greenwich Workshop has also become a major force in the art book field, art licensing and the collectibles world through their porcelain figurine program. The Greenwich Workshop prints are distributed through more than 1,200 art galleries and framers in the United States, Canada and the United Kingdom.

For more information about The Greenwich Workshop or to locate an authorized dealer near you call 1-800-243-4246 in the U.S. or 1-800-263-4001 in Canada.

Hadley House Publishing
Founded in 1975 by Ray E. Johnson, Hadley House Publishing began as a decoy manufacturer and distributor. In 1978, Wildlife artist Terry Redlin became the company's first limited edition print artist and within a few years they became a full-scale publisher and distributor of high quality fine art offset lithographic prints.

Today the company represents more than 30 of the nation's most well-known offset lithographic artists including Terry Redlin, Steve Hanks, Mike Casper, Darrell Bush, Dave Barnhouse, John Seerey-Lester and Charles Wysocki. Their subjects include Wildlife, Landscape, Americana, Portrait and Floral styles.

Hadley House art is available through more than 4,000 art galleries, frame shops, collectibles dealers and gift shops throughout the United States and Canada. For more information about Hadley House, or to find a dealer near you, call 1-612-943-8474.

Mill Pond Press

Located in Venice, Fla., Mill Pond Press is one of the nation's premier offset lithographic publishers. Founded in 1973, Mill Pond Press has long been considered the leader in the Wildlife art field and with the support of its artists and dealers has raised millions of dollars for global efforts to preserve wildlife and wilderness. Today Mill Pond represents more than 30 of the world's most sought-after contemporary artists and releases more than 100 prints per year.

The company began as a retirement hobby for founder Bob Lewin, a former printing salesman who learned his craft by selling candy box wrappers and color brochures. Lewin's desire was to have a business of his own and he started a jigsaw puzzle company, Springbok, which specialized in making puzzles of the world's best art pieces. Eventually he sold the company to Hallmark and retired to the sandy beaches of Florida. But along the way, Lewin had developed friendships with many of the nation's leading artists. After spending a day or two relaxing in the sun he got bored and decided to do a few art prints — so much for the hobby. Mill Pond Press was born.

The first artists to be published by Mill Pond were Maynard Reece, the only five-time winner of the Federal Duck Stamp Competition and Roger Tory Peterson, the renowned ornithologist and author of *The Field Guide to the Birds*. Within a few years, they added Robert Bateman, who has long been regarded as the leading wildlife artist in the world.

Today Mill Pond Press represents many of the nation's most sought-after offset lithographic artists including Robert Bateman, Carl Brenders, Paul Calle, Guy Coheleach, Jim Daly, Peter Ellenshaw, Nita Engle, Rod Frederick, Terry Isaac, Greg Olsen, Arleta Pech, Maynard Reece and Dan Smith. The genres represented run the gamut from Wildlife and Western art; to Fantasy, Floral and Religious art.

The Lewins eventually turned over the day-to-day operations of the company to daughter Laurie Lewin Simms, who continued the tradition of bringing the best artists and the best quality prints to collectors worldwide. In 1998, the company was sold to longtime friend and entrepreneur Rick Mitchell.

For more information about Mill Pond Press or for the name of an authorized gallery near you call 1-800-535-0331.

Somerset House Publishing

Founded in 1972 by Randy Best initially as a non-profit foundation committed to increasing the awareness of contemporary american artists, Somerset House Publishing of Houston, Texas, is now considered one of the leading publishers of limited edition offset lithographic fine art prints. The company was known as American Masters Foundation until 1982.

Somerset represents many nationally and internationally acclaimed offset lithographic artists including G. Harvey, Charles Frace, Tom duBois, Michael Atkinson, JD Challenger, Larry Dyke, Nancy Glazier and L. Gordon. Their genres include Wildlife, Western, Contemporary, Impressionist and Fantasy art.

Somerset House Publishing is actually a merger of three well-known offset art publishing houses: American Masters Foundation, Somerset House Publishing and Frame House Gallery. Today the company is owned by a group of investors headed by Larry Smith.

Somerset is a leader in the offset lithographic canvas art movement and has approximately 3,500 authorized dealers nationwide. To find out more about Somerset House Publishing or to locate a dealer near you, call 1-800-444-2540.

The Magazines Worth Reading

Collector's Mart Magazine

Collector's Mart magazine is the nation's leading periodical focused on the broad scope of collectibles. Each issue is packed with information about prints, figurines, dolls, plates and other gift items as well as timely features about the artists and products that make up the collectibles industry.

The magazine is published six times per year for a subscription fee of $23.98. To subscribe call 1-800-258-0929.

Informart

Informart is a great resource for determining the secondary market values of limited edition fine art offset lithographs. Each issue features an alphabetical listing of current prices, features on selected artists, information about techniques, new releases and shows.

The magazine is a quarterly publication and is available for $24 per year. For more information about subscribing, call 1-203-262-9220.

Southwest Art

Southwest Art is the nation's leading magazine for news and features related to the American West. Emphasis is placed on the artistic trends and philosophies important to the collector, including information about upcoming shows, new releases and techniques. An emphasis is placed on original art and sculpture, as well.

The magazine is issued monthly for $32 per year. Subscriptions are available by calling 1-800-829-3340.

U.S. Art

U.S. Art magazine is the most comprehensive art magazine for offset lithographic print collectors. Structured in a tabloid format, each issue features the artists, shows and new releases that any art enthusiast would find entertaining and informative. If it's important for you to stay on the cutting edge of all genres of prints and print collecting, then *U.S. Art* will be a priceless resource.

The magazine is available monthly through authorized galleries and by subscription. For information about *U.S. Art* magazine call 1-612-339-7571.

Wildlife Art

Wildlife Art is the largest and most widely known magazine dedicated to the world of wildlife art. Features include profiles of artists, both well-known and up-and-coming, shows of regional and national interest and details about new print releases.

The magazine is published seven times a year: January, March, May, July, September, November and December. The cost of a one-year subscription is $28.95. For more information, contact their circulation department at 1-800-626-0934.

The Shows to See

Birds In Art

Hosted annually by The Leigh Yawkey Woodson Art Museum in Wausau, Wisc., "Birds in Art" is perhaps the nation's foremost wildlife art event, featuring more than 100 original paintings and sculptures of birds. The show generally opens in mid-September and continues through October. For more information contact the museum at 1-715-845-7010.

Easton Waterfowl Festival

Every November, Easton, Md., becomes a wildlife collector's dream locale as over 400 nationally known wildlife artists take over the city for the Easton Waterfowl Festival. If your interest is prints or paintings, sculpture or photography, Easton is the place for you. The festival also features hunting and fishing demonstrations, world championship goose-calling contests, seminars and an annual decoy auction.

The show traditionally draws approximately 20,000 people from around the world to the show, which is spread throughout the colonial town of Easton, just 70 miles from Washington, D.C. For more information call 1-410-822-4567.

Florida Wildlife and Western Art Expo

If you happen to be passing through Orlando, Fla., during March don't miss the Florida Wildlife and Western Art Expo. Traditionally more than 100 artists from England, Australia, Germany, China, South America, South Africa, the United States and Canada attend representing the best wildlife, sporting and outdoor art our nation offers. Also, a number of the nation's leading fine art publishers are represented. For more information call 1-941-364-9453.

Masterworks in Miniature

If you'd enjoy the chance to view and perhaps purchase affordable original art pieces by the nation's leading offset lithographic print artists, then you'll want to make a trip to Mentor, Ohio (20 miles east of Cleveland), in March for the annual Masterworks in Miniature art event. Over 125 artists and 200 paintings are traditionally submitted for this unique, one-of-a-kind art event hosted by Gallery One. All works are 9" x 12" and smaller museum-quality masterpieces. For more information call 1-440-255-1200.

Pacific Rim Wildlife Art Show

Featuring more than 120 of the finest wildlife, Western and landscape artists, the Pacific Rim Wildlife Art Show is one of the nation's premier art shows and sales. The show features seminars, quick draws, auctions, workshops, live animal and bird demonstrations as well as thousands of originals, prints and sculpture during its annual three-day public extravaganza every fall in Seattle, Wash.

All participating artists attend the show each year. For more information call 1-253-761-9510.

Southeastern Wildlife Exposition

Every February, one of the largest wildlife shows in the nation is hosted in Charleston, S.C. The show, known as the Southeastern Wildlife Exposition, features wildlife and nature paintings, prints, sculpture, photography and collectibles by many of the nation's most well-known wildlife artists. The Expo generally draws over 40,000 visitors during the three-day event that includes guest artists, lecturers and more. For information call 1-803-723-1748.

~24~

A Final Word About Fine Art Offset Lithographs

The art world has always been filled with talent, imagination, excitement and inspiration, and thanks to advances in the world of offset lithographic printmaking, collectors around the world can now participate in the excitement to a greater degree than ever before.

As the next couple decades unfold, new printmaking technologies are sure to come to the forefront of the industry. Already we are seeing tremendous excitement in canvas art reproductions and the new Giclee printing process. And, there's no reason not to expect that within a few years, people will be able to duplicate original art brushstroke by brushstroke. It's inevitable.

But, as future generations look back at how art prints were able to evolve to that ultimate level of quality, they will recognize that the advent of the offset lithographic art print led the way. It opened up the eyes of the world to how important quality is to the print collecting equation, and it will continue to inspire higher and higher quality for generations to come.

Thanks to the Following

David Benedict, Benedict Insurance

Dan Baker, Crescent Cardboard Company

Donald Boncela, Restorer

Jack Carmichael

Larry Chaffee

The Cheese Man

Ellen Collard, Mill Pond Press

Scott Derengowski, Crescent Cardboard Company

Alice Gibson, *Décor Magazine*

Ray Harm

Charley Harper

Lila Held, Licensed Appraiser

Robert J. Koenke, *Wildlife Art Magazine*

Liz Kriesen

Richard Lewin

Richard J. Mitchell, Mill Pond Press

Seiche Sanders, Krause Publications

Linda Schaner, Mill Pond Press

Priscilla Sharpless, Mill Pond Press

Frank Sisser, *U.S. Art Magazine*

Jim Trombo, Lithographics

Scott Usher, The Greenwich Workshop

David J. Wagner and The Filson Club History Quarterly

Contact the Author:

Jay Brown
7003 Center Street
Mentor, OH 44060

E-mail: art@galleryone.com

Index: